The Texas Cowboy

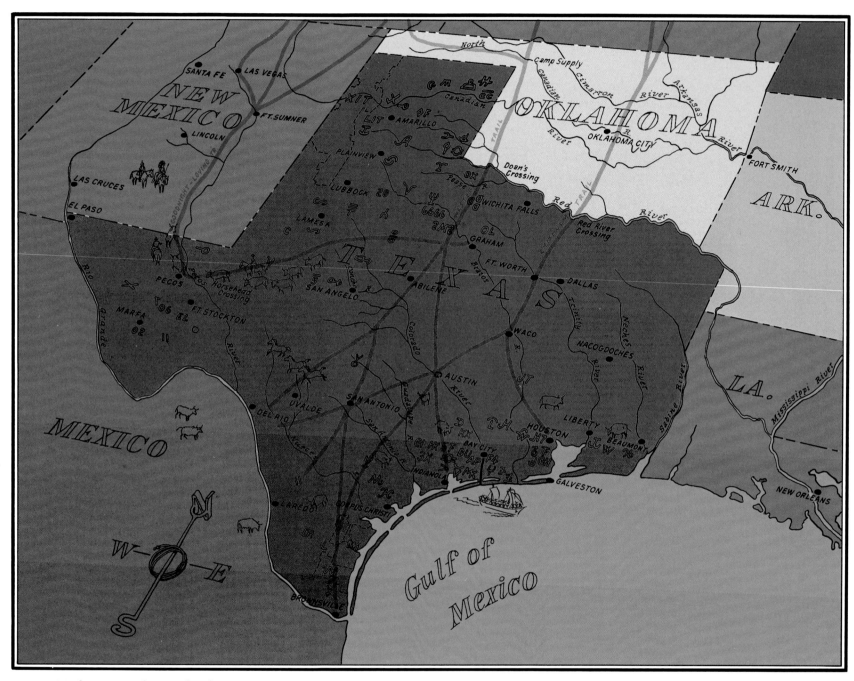

Mark Storm. *The Trails of Texas.*

THE TEXAS COWBOY

By the Texas Cowboy Artists Association

Text by Donald Worcester

Introduction by Elmer Kelton

Texas Christian University Press

FORT WORTH

Library of Congress Cataloging-in-Publication Data

Main entry under title:

The Texas cowboy.
 1. Cowboys in art. 2. Texas Cowboy Artists
Association. 3. Art, American. 4. Cowboys—
Texas—Pictorial works. I. Worcester, Donald Emmet,
1915– . II. Texas Cowboy Artists Association.
N6530.T4T39 1985 758′.99764 85-12544
ISBN 0-87565-022-8

Design by Whitehead & Whitehead, Austin

Contents

To the Texas cowboy, past and present . . .

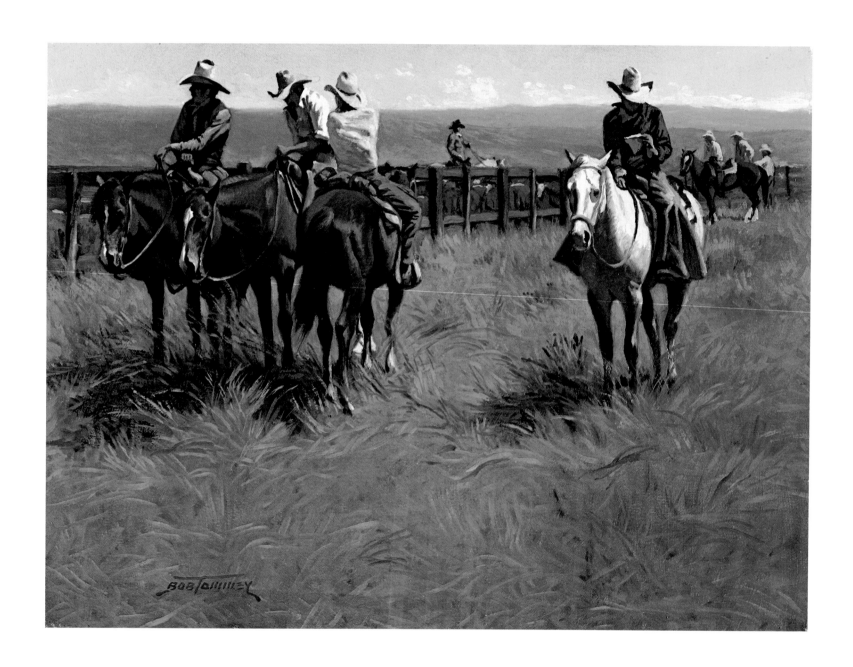

Bob Tommey. *Range Delivery.*

Introduction

EVER SINCE THE FIRST barbed-wire fence went up a hundred years ago, some people have been saying the cowboy is extinct, a remembered relic out of the past. Of late, some have even claimed he was a myth and never existed at all.

That would have been a surprise to my great-grandfather and great-grandmother, who moved from the East Texas piney woods to West Texas more than a hundred years ago with a covered wagon and a string of horses. It would have been a surprise to my grandfather, their first-born, who after his father's untimely death had to go to work at age twelve, cowboying and breaking horses and mules for the Scott & Robertson Ranch in Callahan County to help support his younger brothers and sisters. He punched cattle all the way from the XIT Ranch in the Texas Panhandle to the lower Pecos River before he married.

It would have been a surprise to my great-uncle, his brother, who drifted west before the turn of the century and spent the rest of a long life as a cowboy and ranch manager on the Pecos.

It would have been a surprise to my father, who was a third-generation cowboy and remained one all his life, or to my three brothers who took up the cowboy trade in their younger years and to some degree have held to it.

Myth? Not hardly. When I was a boy at Crane, Texas, some of the old cowboys who still worked or ranched there and in the nearby Odessa-Midland country were veterans of cattle drives up the long trails north. Though I never met him, J. T. McElroy, the founder of the ranch on which I grew up, was a trail driver who saved his wages and became a cowman. He once bought a herd in Sonora, Mexico, and spent two years grazing it two thousand miles to Dodge City, Kansas. The first funeral I can remember attending was of an elderly rancher, a neighbor who was said to have hunted buffalo in his youth and cowboyed later until he saved a stake to go into the cattle business on his own. He was a pioneer cowman in the West Texas sandhills.

The cowboy was a fact of life for me as a boy. Until I became old enough to go to town for school, he was almost the *only* fact of life. I learned very early to identify men by the jingle of their spurs in the yard or on the porch. I was only vaguely aware that any other world existed except that of ranches and cattle, horses and cowboys. Not until I began to read and see the movies did it slowly come to me that the cowboy I knew had been glamourized and fictionalized into something different than he was in my own closely-fenced little world.

Glamour was in short supply where I was used to seeing him, but always there was

something more important: a professionalism, a pride in his ability at his chosen job—or, often as not, the job that had chosen him because he had been born into it and had been given little choice. A man who didn't have that ability and a willingness to use it didn't remain a cowboy very long.

Crane was an oil-patch town. After I started going there every day to school and seeing people beyond those of the ranch fraternity, I was not long in realizing that significant differences existed between the cowboys I knew and the people who lived and worked in town or in the oilfields. At first it was difficult to find much in common with schoolmates whose upbringing had been in an environment in many ways unlike my own. Gradually it dawned on me that the people I had always known were a minority and that the rest of the world looked upon them differently than I did, or than they themselves did. This led to what would be termed an identity crisis in today's self-analyzing society. I was a square peg, and the world was a round hole.

The way I began to understand it, and my place in it, was by reading everything I could get my hands on. Inevitably, because I related to the subject, much of my reading was about the cowboy . . . who he was and where he had come from. I was drawn to writers such as J. Frank Dobie and Will James and found much in them that was familiar because they pictured a world as I had seen it and knew it to be. I also read much of Zane Grey, who told of it not as it was but as it should have been and as I wished it *could* be. All these books, wheat and chaff alike, gave me a new perspective on and respect for the man on horseback. They gave me a better sense of my roots, for my roots were the same as the cowboy's. And though I have seen much of the rest of the world and have known lifestyles totally alien to him, I am always drawn back to him and his. The apple does not fall far from the tree.

From reading that I started when I was still too short to reach the stirrups without something to climb up on, I know the cowboy as he is popularly envisioned today came into his own in the economic and political turmoil that followed the Civil War. His actual genesis was far earlier. A case might be made that it goes back as far as the great cattle herds of the Biblical Abraham, and surely someone even older had to teach Abraham about the cow. Some of the cowboy's working techniques were established in Spain and imported to the New World as the great haciendas sprawled across Mexico toward the Rio Grande and the land that was to become known as Texas.

It is an oversimplification, however, to say that the cowboy we know is a product of Mexico, just as it is simplistic to say the Texas cattle industry came from there. The Anglo cowboy as he came into being in Texas and then spread across the West was a cross-pollination of the Mexican influence and cattle-handling techniques which came into early Texas from the middle Atlantic states and the Southeast, just as early Texas cattle tended to be a combination from the two sources. Given the racial bitterness engendered by two wars with Mexico, the early Anglo cowboy would have rejected any indebtedness to that country, however honest the debt might have been.

The classic period of the cowboy is popularly regarded as the open-range era, but in a strict sense that era was very short. If you accept that the cowboy came into his own just after the Civil War, and realize that fencing began on a large scale in the early 1880s, you must concede that he had less than twenty years of open-range existence. That is barely time enough for a young man to advance into middle age.

The truth is that the Texas cowboy existed long before the Civil War, but working techniques were still haphazard. There was no accepted manner of doing things, no "official" uniform of the trade. Many Anglo colonists who came into Mexican Texas under Stephen F. Austin and other land empresarios brought small numbers of cattle, which they raised mostly for their own use or for local markets because there was no practical way to transport them long distances, even if prices had justified doing so. The Texas cattle industry began to manifest signs of its future bigness after the Texas revolution and particularly after the Mexican War. In southern areas this tended to be along the Mexican style and with Mexican cattle. In northern areas the early influence was from states to the east. In time these two styles began to fuse and evolve into something that was some of each and some of neither.

Though it is popularly supposed that trail driving began after the Civil War, the truth is that hundreds of thousands of Texas cattle were trailed to New Orleans and farther during the preceding decade. Drovers who undertook the Chisholm and other well-known trails in the late 1860s and 1870s had the benefit of lessons learned by men who had driven cattle to Missouri, Illinois and to the Colorado goldfields in the 1850s. Somehow, though, that early period missed the romance and glorification which attached itself to the cowboys who pointed their herds north for the later drives. Few if any novels were ever written, paintings ever made or movies ever filmed about that early stage of the cowboy's development. It is clear that the people of that time indulged in no rosy-hued euphemisms.

The Newcomb diaries from old Fort Davis on the Clear Fork, for example, describe cattle work by Texas frontier settlers during the early part of the Civil War in the darkest terms of hard work, deprivation and forebodings of Indian danger, without an ounce of romance or derring-do. Neither do they mention the word *cowboy*, which in its beginning was used in a derogatory sense. Some early practitioners of the trade resented being called cowboys. It took years for the term to purge itself of early connotations.

Almost as soon as the cowboy began to be glorified by dime novelists after the war, his death notice was being written. When Charlie Siringo published *A Texas Cowboy*, the first noted cowboy autobiography, in 1885, he seemed to feel that the cowboy was already passing over the hill. Later writers expressed the same judgment, though each saw the golden era as a different period and the sunset of the cowboy as having been toward the end of his own active years, whenever that happened to be.

Various writers have documented the end of the true cowboy as having come with barbed wire, or at the turn of the century with Teddy Roosevelt and his Rough Riders

having been the last hurrah before the whole country went to hell in an automobile. Later writers said goodbye to the cowboy in the twenties and the thirties, when the booming petroleum industry drew many away to higher-paying work in the oilfields. Today some feel he came to an end with the call-up of men for World War II or with the great drouth of the 1950s, which drove so many people off the land. Not long ago I heard a veteran of the 1950s foot-and-mouth-disease campaign in Mexico declare that to have been the swan song of the true cowboy.

Meanwhile, not having read his obituary, the cowboy continues to thrive, his working methods and routine changing with the times and the technology but his general outlook on life still much the same as his grandfather's and great-grandfather's.

My great-grandfather lived and worked in what is often regarded as the cowboy's golden period, the first two decades after the Civil War. He died almost forty years before I was born, but I believe that if he were somehow to be brought back for a visit today, we would understand each other and agree on a wide variety of subjects. More importantly, he and my own grandchildren would probably relate to one another very well.

Texas writer John Graves has made the point that an 1870s cowboy transplanted into the 1930s would have seen little basic difference except a few superficial changes such as automobiles and barbed-wire fences. Many 1870s cowboys were still living in the 1930s; they had survived the transitions.

The late Irvin Ellebracht of Mason, Texas, told me a story about some oldtime cowboys in the hill country. Irvin was a latter-day trail driver of the 1920s, driving herds of shipper cattle on contract from the Mason area to railroad pens at Brady to the north or Llano to the east, most drives averaging thirty to forty miles and taking three or four days. One time three old cowboys, veterans of the great trail drives to Kansas, asked if he would let them go along with him to Llano. Just for old times' sake, they wanted to experience one more drive before they died. A little concerned about the responsibility but not wanting to disappoint three grand old men, he said yes.

The drive went along smoothly most of the way, and the old fellows had a glorious time reliving their youth. But the last day out a storm blew in. Rain fell in sheets, and by the time the herd reached the Llano River the water was rising. Not knowing how long the rise might last, Irvin decided to put the herd across while he still could. Under the pressure of the immediate task he forgot about the old men. When the herd was safely across the river, he suddenly became aware that all three were missing. With dark misgivings he asked the other riders if they had seen what happened to the old drovers. They had all been too busy to notice. A frantic search was begun downriver, for now it appeared likely the three had been swept away. No sign of men or horses could be found.

Just as Irvin was about to send for extra help to broaden the effort, the three oldtimers rode up on the east side of the Llano. While everybody else was busy swimming cattle, they had ridden downriver to a wooden bridge.

"That," Irvin told me, "is how they got to be *old* trail drivers."

Cowboying has changed more in the fifty years since the 1930s than in the fifty before that period, but the cowboy himself retains much in common with his great-grandfather of a century ago.

My grandfather was of the second cowboy generation, born barely ten years after the war and working as a young bachelor in the era when barbed-wire fences were just beginning to close in the open range. Remembering conversations we had in the eighteen years I was privileged to know him, I see little basic difference between him and the modern generation of cowboys except in mobility and the tools of their trade. He did his ranch work a-horseback or with a spring wagon, but he never had any quarrel with my father's use of a pickup and horse trailer. Granddad would probably shake his head in disbelief if he could watch today's cowboys practice artificial insemination or embryo transplanting, but when the work was finished and they sat down to sip coffee and sort out solutions to the world's problems, he would be right at home among them. They would savvy each other because the great common denominator would still be there: they would all know the cow, and they could all talk horse.

That, basically, is what the cowboy has always been about: his work. He was good at it or got out. Labor shortages on the ranch are a product of the years since World War II. Before that, there was never more than a temporary and usually local shortage of good cowhands anywhere in the ranching country. Competition for jobs forced a cowboy to be worth his hire or to seek some other employment.

For this reason, cowboys in an earlier day judged a man first by how well he rode a horse and by the way he handled cattle, not by how much money he had or how much land he owned. If he could ride a rough bronc without pulling leather, could consistently rope a cow brute with the first throw and always carried his weight wherever work was being done, he was a good man. He could be forgiven shortcomings in the social graces, even lapses in his relationship with the law. But a man who owned a thousand cattle yet could not work them without spilling half the herd, or sat in his saddle like a sackful of grain, was not held in high esteem. And a man who lived and worked in town, even if he owned the bank, was pitied if he was not hand enough to hold a riding job.

It is still pretty much that way. If you want to win a cowboy's respect, forget your bank balance, your academic titles, your plaques of appreciation from the Junior Chamber of Commerce. Show him you know the proper way to get on a horse.

The McElroy Ranch, where I grew up, was operated like any conventional cow outfit except that in reality it belonged to the Franco-Wyoming Oil Company, which was extracting millions of dollars from beneath the ground compared to relative thousands from the grass on the surface. We were visited frequently by company executives from the two coasts and by major stockholders from France, whose peculiar language always made us wonder how they knew what they were talking about. It did not matter that any of those people earned more money in a day than most of the cowboys saw in months.

The cowboys still snickered and felt superior; there wasn't a one of the dudes who knew how to head a cow down a fence.

The romanticizers always tended to paint the cowboy as a knight on horseback, a latter-day reincarnation of Sir Walter Scott's chivalric figures. The detractors, on the other hand, wanted to paint him as just another hired hand, like the dumb brute in the classic painting of the man with the hoe, except that he did his work on horseback. To one, the cowboy embodied all that was free and noble and exalted in mankind. To the other, the cowboy was unschooled and unwashed, a man who did a dirty job because he lacked the intelligence for anything better.

The cowboy as I have known him for most of sixty years fits neither pattern. For one thing, either picture implies a sameness in him, a uniformity that never existed. The cowboy as I know him has been an individualist first of all. There is no typical cowboy. Pick any individual out of a ranch corral or a rodeo arena and he will present contradictions to the classic mold.

The ones I knew in my youth usually ran counter to the popular image in many ways, not the least of them in their fighting ability and their marksmanship. In all the time I was growing up around cowboys, I saw only two cowboy fistfights, neither of them resulting in anything worse than a bloody nose. Most ranchhouses and bunkhouses had a rifle or a shotgun, but few had a pistol. Hub Castleberry, a chuckwagon cook, used to keep a pistol in his chuckbox, for what reason I never knew. One day one of the best cowboys I ever knew borrowed that pistol to kill a beef. I saw him miss three shots, though he was standing close enough to have clubbed the animal with the barrel.

The cowboys I knew were all different. From my earliest recollections come some who drank too much, and some who never lifted a bottle to their lips. There were cowboys so profane that they could not say four words without blistering the ears. There were cowboys who never said *damn* where God could hear it. I remember cowboys who read a newspaper but slowly, running a finger along the lines and moving their lips while they frowned over the words. Others read from a collection of classics that the manager had placed on a bunkhouse shelf. There were cowboys who put women on a pedestal and never spoke to them without taking off their hats. There were others who never went to town on Saturday night without throwing a blanket into the bed of the pickup.

There were regional differences as well. The cowboy of the West Texas sandhills worked cattle differently in some respects from his counterpart down in the South Texas brush country or up on the wide-open plains, much less far to the north in Wyoming or Montana. Climate, terrain, even local customs and history dictated adaptations that stamped a man by where he came from. The "utility" West of much fiction, and especially of films, was a vague catchall place that could be called Arizona one time and North Dakota the next without changing a line of the story or moving one prop from the scenery. In truth, the differences could be substantial.

When the horse Indians were driven out of the Texas Panhandle in the fall of 1874 and the region opened for white settlement, many of the first cattle turned upon the former buffalo range came from the brushy regions of South Texas, driven to a new country by cowboys who had always worked in the thick mesquite and chaparral. It is said that many found the plains too wide open, that they felt exposed and vulnerable and never were able to make the psychological adjustment to vistas that stretched for mile upon mile and a wind that never stopped searching. By the same token, cowboys from the open country often tried and failed to adjust to the claustrophobic limitations of the dense brushlands, where they might catch one quick north-end glimpse of a southbound steer and have to rope him in the first available twenty-foot clearing or lose him.

By necessity, the tools and even the clothing have had to fit the country in which they were used. One subtle difference I noted even as a boy was that the men who commonly worked in the brush usually wore their spur leathers buckled to the inside where a limb was not likely to jerk them open and cause the loss of a spur. In the open country where my grandfather lived, on the lower plains, most wore the buckles on the outside.

Looking in a ranch-equipment catalog that used to come from Denver, I was intrigued by pictures of Angora chaps, made of goatskin with the hair still on it. Having never seen a cowboy wear such a getup, I asked one of our West Texas hands about it. He assured me it was simply something out of the movies. He was wrong, of course. Angora chaps were common for years on northern ranges where they helped protect the legs from bitter cold. They would have been useless in the Texas brushlands, where rough limbs and long thorns would have made short work of those pretty ringlets. The cowboy I asked had never been north. His knowledge, like mine, was limited to the West Texas region where he had always lived and worked.

Other regional differences included the kinds of saddles, whether centerfire or double-rigged, and even styles of roping. In California and other western areas, ropers "dallied" around the horn to hold an animal after catching it. In the country where I grew up, most were "tie-fast" men. Dallying was considered too dangerous because a cowboy could too easily catch a finger between rope and horn and lose it. Dally ropers considered the hard-and-fast tie too dangerous because there was no easy way of getting loose from an animal that turned out to be too much to handle. I have seen a cowboy with one end of his rope tied fast to the saddlehorn catch a bull that outweighed his horse by two to one. There is no way to throw that kind of ballast overboard in case of a storm.

Better communications and greater mobility have done much to compromise superficial regional differences in recent generations. As modern transportation has made it easy for cowboys to move from one region to another, clothing and working outfits have standardized to a great extent. Some big Texas ranches own lands in Wyoming, Mon-

tana or the Dakotas to which they send stocker calves of their own raising in spring to be grown out into big feeders on summer grass. Often they send their own men with the cattle. These hands take their ways with them and let them rub off on men among whom they work on the northern ranges. By the same token, some of the northern influence rubs off on the Texas cowboys, and they take it home when they head south just before the snow flies.

Rodeo has had much to do with the amalgamation of cowboy accoutrements, too, so a Texas rodeo hand feels at home in an arena in Billings, Montana, or Calgary, Canada, and a Canadian calf roper is at ease in Fort Worth.

Cowboys would not want to admit it, but they have probably been influenced as much by Hollywood as Hollywood has been influenced by them, especially in their clothing. Old cowboy photographs by such early horseback cameramen as Erwin E. Smith or L. A. Huffman show no fancy outfits, not even any particular common denominator beyond their high-heeled boots to distinguish the cowboy from the muleskinner or the freighter, who was likely to wear even the same hat.

I have an old 1890s picture of my grandfather with three other young cowboys who trooped down to the photo studio in Baird, Texas, on one of their occasional days in town and posed in their working clothes . . . boots, big hats, spurs . . . but nothing stylish or flashy. They had no particular image to live up to. Owen Wister's *The Virginian* had not yet been published, and Hollywood was years away.

When William S. Hart was making silent Western films, his cowboys looked as if they had just been bucked off and stomped on. But along came Tom Mix, who knew a good haberdasher when he saw one, and style came to the forefront in Western films. It soon followed in the rodeo arena and then on the range.

Moreover, styles kept changing, as often as not in the films first and filtering down to the working cowboy. Most Western films purportedly are set in the same general time period, so theoretically the costumes should be the same whether the films were made in the 1930s or last year. This is not so, as even a cursory survey of the late show will readily reveal. A Western film connoisseur can tell within a few years of the time a movie was made simply by looking at the costumes. By the same token, pictures made of real cowboys in the arena or on the range can usually be dated by the clothes they wear and the styles of their hats. Up to a point, they will usually parallel Hollywood.

In recent years, since the Western film has gone into eclipse, the biggest fashion setter seems to be the rodeo arena. A number of large Western-wear firms promote styles among rodeo cowboys, and these work their way down in fairly short order to the Western stores and saddleshops which are today's cowboy fashion headquarters. The rodeo industry itself recognizes that the cowboy has a salable image to be protected and promoted. The Professional Rodeo Cowboys Association has a rule that its members must appear in conventional Western garb when they perform in an arena. They are even required to wear a Western-style hat—no "gimme" caps or bare heads. You'll no-

tice that many a roper pushes his hat to the back of his head as he settles his horse into the box so the hat will fly off and be out of his way when he swings his loop. He observes the letter of the PRCA rule, if not its spirit. Around the country ropings, where professional regulations do not apply, more ropers will wear gimme caps than hats.

The costume is superficial in any case. It says little about the man who wears it, beyond the fact that he may be trying in some ways—consciously or unconsciously—to live up to the legends and exaggerated expectations of a general public that really knows little about him. The man himself still defies pigeonholing into any narrow definition, any handy generalization. He remains an individualist, even if he has somehow let himself be beguiled into accepting what amounts to a uniform of his trade.

It has been an honest uniform, in the past. It used to be that a man who dressed like a cowboy probably was one, because non-cowboys somehow recognized this was a badge of distinction that a man had to earn. A "jellybean" who was no cowboy but tried to look like one was usually ridiculed and scorned. I was always a poor excuse of a cowboy myself, despite the best efforts of my father and a lot of good hands to make one of me. Therefore as a boy I was always reluctant to dress too much like a cowboy in town; I didn't feel I had earned the right. That feeling persists, one reason I seldom ever wear boots until there is a genuine need. But today, of course, the urban cowboy is around everywhere, driving a high-set "dooley" pickup and wearing snuffbox holes in his hip pocket.

The real cowboy is seldom fooled. The knowing eye can drift over the honkytonk imitations and pick out the genuine article. The difference may be subliminal, sensed as much as seen, but it is there.

A joke which has recently made the rounds illustrates the true cowboy's feeling about all this flattery by imitation. It tells about the old hand who always puts on a gimme cap and tennis shoes when he goes to town because he doesn't want to be mistaken for a truckdriver.

If the cowboy has often been falsified by Hollywood, by fiction writers, glorifiers and debunkers, he has usually been well-treated by the serious artists of the West. This is not to say that they have not been selective in what they chose to paint or sculpt. Charles M. Russell was accused by his contemporaries of painting his cowboys "too pretty," and Will James' horses were usually two grades better looking than those we ever had around the McElroy Ranch.

Nevertheless, today's better painters and sculptors are serious about authenticity, about showing the West in general and cowboy life in particular as it was or is. They give careful attention to detail, studied in museums and old photos in the case of historical subjects, often studied from on horseback in the case of contemporary subject matter. Many of today's Western artists are cowboys by upbringing or by choice, at least to the extent that they know from experience the bite of first light at the back side of a pasture on a frosty February morning, or the heat and dust of a branding pen in August.

They know the satisfying feel of a good, dependable horse beneath one's saddle, or the tension that comes from not knowing when and which way a raw bronc is going to jump. By knowing, they convey not just the photographic image but the human emotion behind it.

The "official" art critics tend often to search for abstractions and subliminal meanings, criticizing Western art because it looks like what it is supposed to represent. If the masses can understand it, it can't be worthwhile, they seem to say between the lines.

Perhaps the best critic for true cowboy art is the true cowboy. I have attended many Western art shows in recent years and have listened to cowboys discuss the works that portray their daily lives. They usually cut right through the pretensions and get down to bedrock. Few are quite as cutting as the late Dr. Ben K. Green, who once was giving an artist's work a long, frowning study at the National Cowboy Hall of Fame. The painter stood nearby, nervously trying to read his mind. Unable to stand the suspense any longer, he introduced himself and asked the good doctor what he thought.

Declared Green caustically, "Well, son, if you'd chop up them frames, they'd make damned good kindlin' to burn the rest of it!"

Most cowboys will say little or nothing but simply waste no time on works they find wanting. The greatest compliment they are likely to bestow is, "The feller that painted this has been there."

The artists who contributed to this pictorial history of the cowboy have been there.

Elmer Kelton
San Angelo

The Texas Cowboy

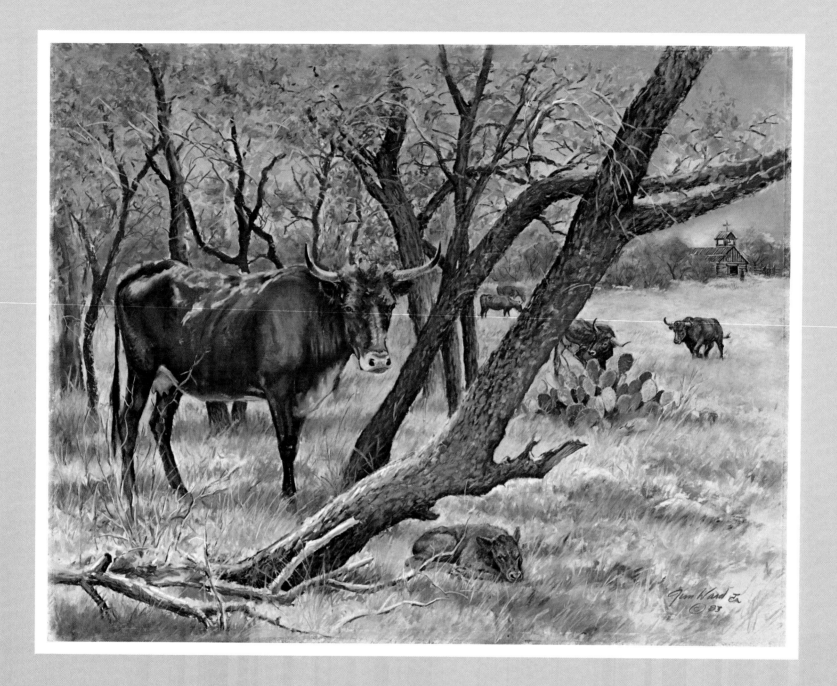

Jim Ward. *Spanish Mission Cattle.*

The Texas Longhorn

E VEN BEFORE THE SPANIARDS brought cattle and horses to Texas in 1690, the Indians of East Texas had acquired a few horses through trade with the Pueblo tribes of New Mexico. These tribes, in turn, had gotten horses from the Spaniards who colonized New Mexico shortly before 1600. Spanish expeditions searching for La Salle's colony in Texas in the 1680s lost cattle and horses along the way, and these lost animals thrived in the wild. In 1690 Alonso de León escorted a group of padres who were to establish three missions among the Tejas, a Caddo tribe of East Texas. They brought cattle, mainly of the Retinto breed of southern Spain, with moderately long horns and ranging in color from Jersey tan to red to brown and occasionally black.

The padres abandoned the missions in 1693; when they returned in 1716 they found that the cattle and horses left with the Indians had multiplied prodigiously. The padres withdrew again a few years later and reestablished their missions near the presidio of San Antonio de Béxar and the mission of San Antonio de Valero. The four San Antonio missions kept herds of livestock under the care of mission Indians.

In 1731 sixteen families of Canary Islanders were brought to Texas, where they founded the Villa de San Fernando de Béxar, the first civil jurisdiction in Texas and the forerunner of modern San Antonio. Private ranches were located around the new villa and along the San Antonio River toward the mission ranches at La Bahía (modern Goliad).

The Spaniards found Texas ideal for stock raising, for there was plenty of grass for thousands of cattle and horses as well as for the vast herds of buffalo. There were also many elk, deer, and antelopes along with predators such as bears, wolves, coyotes, and panthers. In the early nineteenth century Lieutenant Zebulon Montgomery Pike described Texas as "one of the richest and most prolific and best watered countries in North America." About the same time, Spanish General Bernardo Bonavía called it a "prodigious and beautiful land."

Because of Apache and Comanche hostilities in the eighteenth century, ranch and mission herds were often neglected for several years at a time. Cattle and horses strayed and joined wild herds. The wild cattle were so wary and swift, and so fierce when wounded or cornered, they were hunted like big-game animals; few of them could be caught and domesticated.

In the 1820s and 1830s Anglos brought other cattle with them to Texas. Men com-

ing from Tennessee and Kentucky undoubtedly brought some British Longhorns, for they were the most popular breed in those regions.

Early Anglo cattlemen built up their herds gradually, largely by natural increase. By 1824 some men had herds of a hundred or more, and each year thereafter the size of these herds increased rapidly. There were thirty-five hundred cattle in the Austin Colony in 1826, but by 1831 the number had risen to twenty-six thousand. Texas cow-men drove small herds of steers to New Orleans for sale, where they were used locally or shipped to the West Indies.

During the Texas Revolution ranchers provided large numbers of cattle for the Texas army, and Santa Anna's troops drove off hundreds. Still, most ranchers retained good-sized herds. For example, the Kuykendalls, who had brought seventy cattle to Texas in 1822, still had two thousand head left when the war ended, despite heavy losses during the fighting.

After the Texas Republic was established in 1836, men called "Cow-boys" raided Mexican ranches between the Nueces and the Rio Grande, a part of Mexico known as the Nueces Strip. They ran off thousands of cattle and horses. This probably allowed the first large-scale mixing of Spanish and Anglo cattle. The product of this mixing was the multi-colored Texas Longhorn.

After the Treaty of Guadalupe Hidalgo in 1848, the Nueces Strip was declared part of Texas, but the treaty did not erase the old border in the minds of many Mexicans. The strip became a raiding ground for bandidos such as Juan Cortinas, who plagued ranchers, terrorized Brownsville, and generally kept the state of unrest high along the Rio Grande for many years before and after the Civil War. In 1875, the Texas legislature authorized a special force of Rangers under Captain Leander H. McNelly for the sole purpose of stopping depradations along the Rio Grande. The severe methods of Captain McNelly and his Rangers—emptying many saddles and chasing raiders across the border—combined with the work of the Rurales (rural police) on the Mexican side reduced raiding, and ranchers in the strip restocked their ranges; towns grew up among the mesquite and cactus.

Mustangs—Spain's Gift to Cowboys

UNBRANDED WILD HORSES were called *mesteños*, meaning that since there was no evidence of ownership they belonged to the *Mesta* or stockmen's association. Anglos would corrupt *mesteño* into mustang; *mesteñeros*, men who hunted and caught them, became mustangers.

Mustangs roamed in bands of from fifteen to forty mares and colts. Each band was jealously guarded by a powerful stallion that frequently had to fight off rivals. As a result, only the best stallions sired mustang colts, which prevented the type from degenerating.

Each band had its customary range, which might extend for fifty or sixty miles. Unlike cattle, which were likely to wander far from where they were born, mustangs always remained on their own range. This made it possible for mustangers to station riders at different places and follow a band in relays until the animals were exhausted and could be driven into a corral. Stallions always stayed between the band and pursuers, in part to protect the mares and colts, in part to prevent any from lagging behind.

When domesticated animals live in a wild state for years they tend to revert to ancestral types, which accounts for the colors and qualities found in the Texas mustangs. Mustangs were of great variety of colors—black, white, bay, gray, pinto, red and blue roan, sorrel, and palomino. There were also duns, buckskins, and grullas, the color of sandhill cranes. Duns and grullas usually had dark lines down the backs and horizontal "zebra" stripes on their legs. Many also had vertical stripes at the shoulders. Duns and grullas were especially known for their endurance, and cowboys were eager to own them.

Although wild cattle hid in the brush by day, mustangs preferred open country. When foals were born, the other mares stood around the mother and her newborn to protect them against coyotes and wolves. In a few hours the foals were usually able to run by their mothers' sides.

By the 1820s, when Anglo colonists came to Texas to settle on the empresario grants of Stephen F. Austin and others, there were thousands of wild mustangs. They were fairly easy for vaqueros to catch and break, and they provided saddle mounts and cow ponies for the Anglos as well as the native Tejanos. They were typically small and weighed less than a thousand pounds, and they were so numerous that no care was taken in catching or breaking them. Mexican vaqueros handled them so roughly that many were crippled and ruined. Those that survived made excellent cow ponies and

even cavalry horses. Some were also remarkable for their patience in waiting for opportunities to avenge themselves, and stories of "mustang tricks" were told by many frustrated travelers. When humanely treated they were usually loyal and dependable, and many a cowboy owed his life to the keen senses of his mustang cow pony.

Indian ponies were also mustangs, and they thrived on hard usage. Army officers considered Plains warriors on their best war ponies the finest light cavalry in the world. If a cavalry unit couldn't overtake a band of Plains Indians in two hours, further pursuit was useless, for the Indian ponies could keep going for ninety miles.

Tame mustangs were not noted for their beauty, but in their wild state the horses invariably impressed travelers. With long manes and tails flowing, they playfully circled traveling parties, as if reveling in their freedom. Often they came so close that loose animals and pack mules dashed off with them. Horses and mules that joined wild bands often became warier and more difficult to catch than wild mustangs.

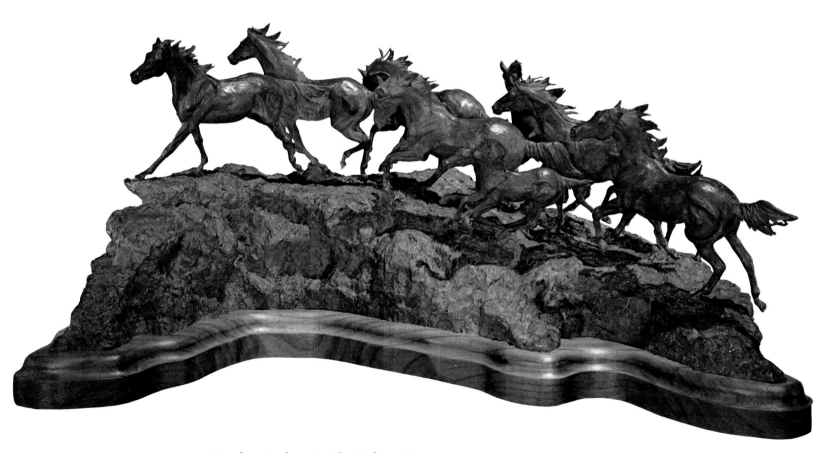

Cynthia Rigden. *To Fly Without Wings.*

Vaqueros—The First Cowboys

BORN IN OLD MEXICO, vaqueros rode the Texas ranges from around 1700, perfecting techniques for handling cattle and mustangs in the brasada or brush country as well as on the open plains. Anglo cowmen who came to Texas in the 1820s and 1830s as members of the Austin Colony or similar empresario grants often employed Tejano vaqueros. From them, they learned to rope cattle and horses with rawhide riatas, to catch and break mustangs, and to ride with a big-horned saddle. No longer did they use long whips and herd dogs to work cattle.

A century and a half later Texas cowboys still use the equipment and practices borrowed from the vaqueros. Over the years they have made some changes and improvements, but the riding gear serves the same basic purposes. Big-roweled Chihuahua

Bill Leftwich. *Vaquero.*

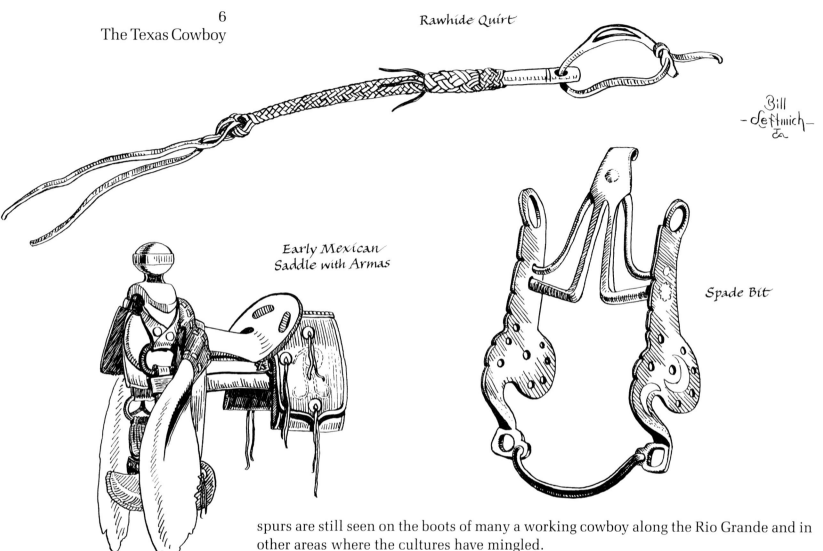

Rawhide Quirt

Bill
-Leftwich-
a

Early Mexican
Saddle with Armas

Spade Bit

spurs are still seen on the boots of many a working cowboy along the Rio Grande and in other areas where the cultures have mingled.

The vaquero's horned saddle evolved gradually from Moorish and Spanish war saddles into one suitable for use in handling cattle on the open range. In the brush country vaqueros used leather armas to protect their legs from the rich variety of thorns. Armas are used in parts of Mexico today. Vaqueros also devised chapareras or botas de ala, which old-time Texans referred to as "leggins" and which today are called "chaps." On their stirrups vaqueros attached leather toe fenders called tapaderos to protect their feet, and these "taps" are still used in the brush country of Texas and Mexico.

The catch rope and saddle horn were among the vaquero's greatest contributions to later cowboys. Riatas of twisted rawhide were replaced by braided rawhide riatas from forty to sixty feet long. Maguey or "grass" ropes were developed later; these and raw-

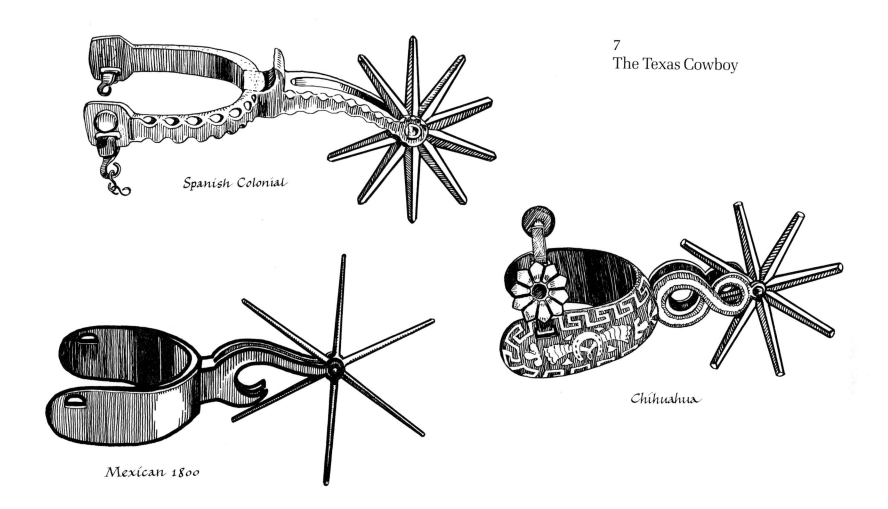

Spanish Colonial

Mexican 1800

Chihuahua

hide riatas were eventually replaced by Manila hemp and nylon lariats. Vaqueros had earlier abandoned the Spanish noose-on-a-stick method of catching cattle and horses in favor of throwing the loop over horns or head.

Early vaqueros tied bandanas around their heads or wore flat, low-crowned hats of leather, felt, or straw. Anglo cowboys adopted the felt or straw hat as well as the brush jacket of leather or heavy cotton.

The Mesta or stockmen's association was introduced into Mexico from Spain in 1529. The Mesta established rules for registering brands, conducting roundups, and disposing of unbranded strays. The famous cross and crescent brand, one of the first in the New World, was registered in Mexico City in 1529. Unmarked cattle were called *orejanas*, meaning that they lacked identifying earmarks.

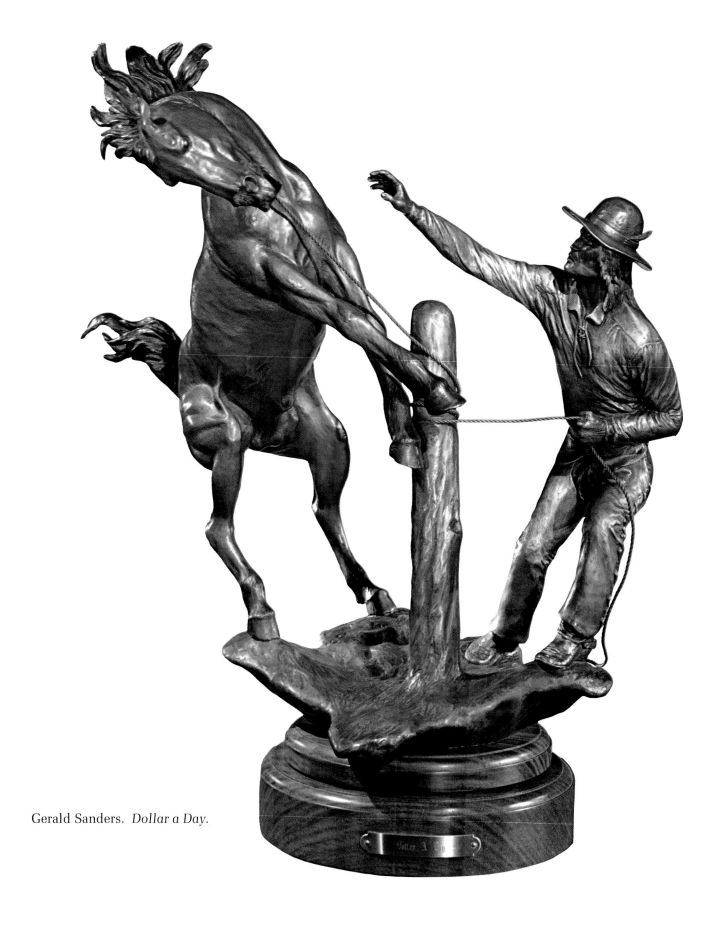

Gerald Sanders. *Dollar a Day.*

Birth of the Texas Cowboy

MANY OF THE SOUTHERNERS who came to Texas in the 1820s and 1830s were experienced in handling range cattle and horses. Their cowboys, usually slaves, used dogs to round up cattle and wild horses and drive them into cowpens. In the pine forests of East Texas, their methods were appropriate. When taking small herds of steers to New Orleans, they had a man lead a belled ox for the cattle to follow, as they had done in the South. But on the open plains, the practices of the Tejano vaqueros were more suitable.

Until the Texas Revolution caused many colonists to flee, leaving their cattle to stray and become wild, Anglo ranchers followed the Tejano practice of rounding up their cattle once a week. They circled their ranges, pushing the cattle to some central gathering ground, then let them scatter again. The cattle became accustomed to the practice and headed for the gathering ground when they saw riders circling them. This weekly roundup kept the animals from straying or becoming difficult to handle.

Anglos and their slave cowboys became adept in roping both cattle and horses. They borrowed not only the techniques and horsemanship of the Tejanos but also their terminology. Cowpens became corrals; vaquero was transformed into buckaroo; and ropes became lassos or lariats. Chaps, broncos, mustangs, sombreros, and hackamores were also terms made over or adopted from Spanish words.

Mustangers and Bronc Busters

THE FIRST MUSTANGERS (*mesteñeros*) were Tejano vaqueros, who rounded up wild mustangs to break and sell or use for breeding stock. A vaquero roped a mustang, placed a heavy and severe bit in its mouth, saddled it, and climbed on. He spurred it and made it run until exhausted, rested it briefly, then forced it to run back the way it

had come. If it survived this harsh treatment, it was branded and turned in with other saddle stock.

Anglo mustangers appeared in Texas even before the Austin and other colonies were established. For instance, Philip Nolan made several trips to Texas to catch or purchase mustangs in the 1790s. When Anglos settled in Texas, they continued catching mustangs. Occasionally larger American stallions escaped from ranches or wagon trains and joined the wild bands. As a result, the mustangs in some regions were larger and more difficult to catch and break than the typical ones.

To catch a whole band, mustangers built stout corrals with an opening leading into a smaller pen, so the mustangs would run into it while men closed the gate. They se-

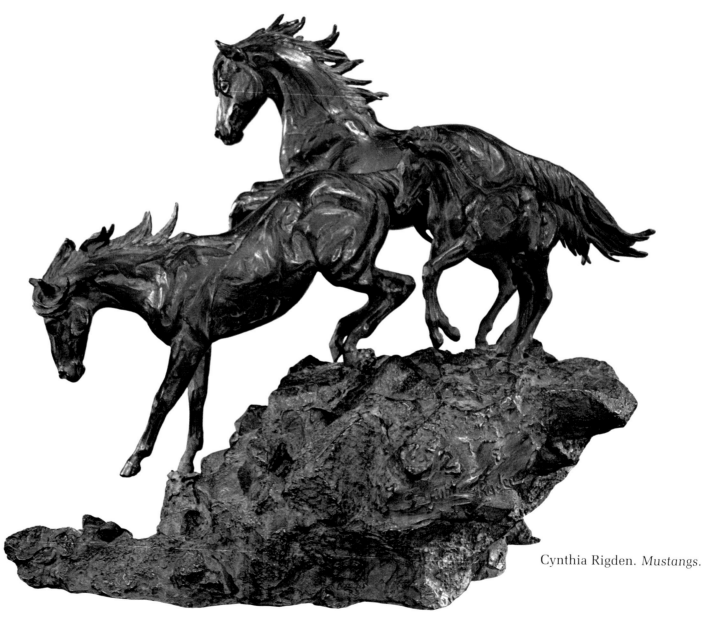

Cynthia Rigden. *Mustangs.*

lected a band that ranged the region and determined its regular grazing ground so that relay riders could be stationed at appropriate places. One rider started after the mustangs, which raced away the moment he came into sight. They might run twenty or thirty miles before turning back, but they wouldn't leave their customary range. The rider followed the band until his relief appeared. By preventing the mustangs from resting or grazing for several days, the riders were able to corral them. They tied clogs to the animals' legs so they couldn't run, and in a few days were able to herd them easily.

11
The Texas Cowboy

Mark Storm.
Wild Horse Country.

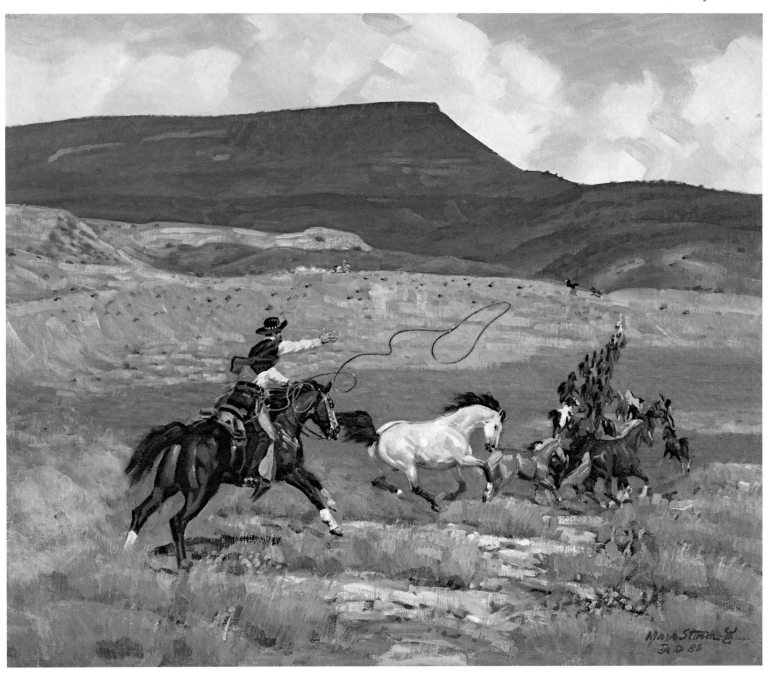

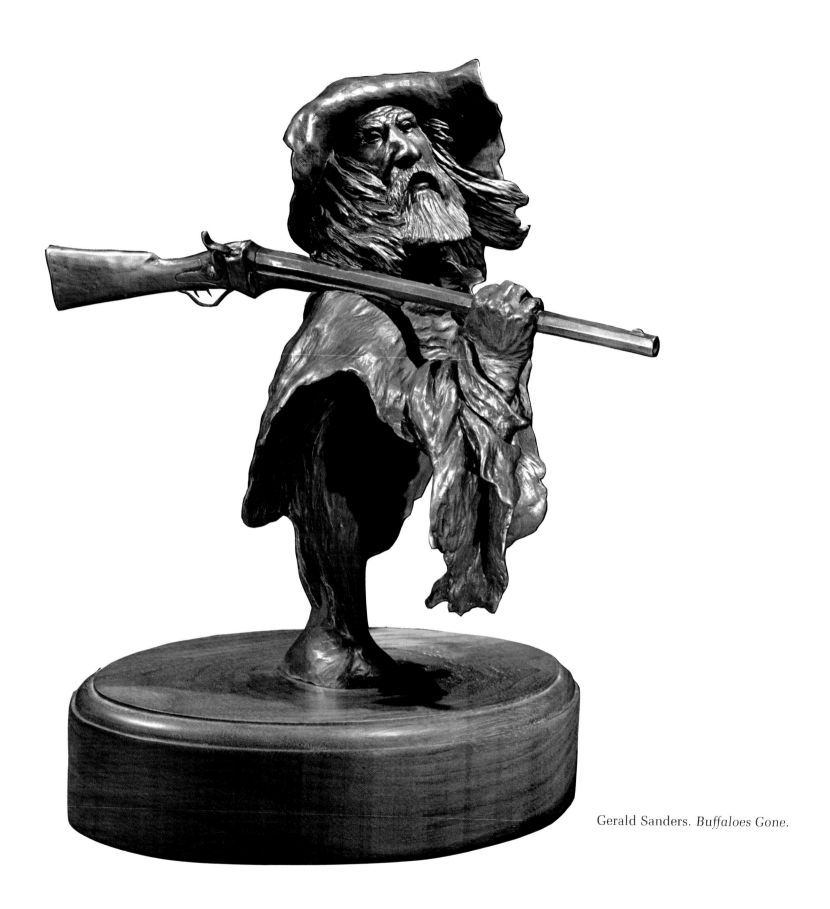

Gerald Sanders. *Buffaloes Gone.*

The Indian—A Threat Vanquished

PROTECTION OF FRONTIER FAMILIES and settlements against Indian attacks was a continual problem for Anglo colonists as it had always been for the Spaniards. Raiding parties struck without warning, sometimes a number of them at once and over a wide area. For this type of warfare there was no general defense. If there was time, several families forted up together; otherwise each family had to fend for itself. About all that could be done was for local men to raise a force of volunteers called *rangers* to pursue raiding parties and try to rescue captives and recover horses and mules. Occasionally fairly large forces of rangers followed the raiders several hundred miles and attacked their camps. These punitive expeditions, if successful, might bring peace to the frontier for a year or two, but they accomplished nothing permanent. Under the Republic, ranger companies were recruited and stationed on the frontier for several months at a time, but they couldn't check the incursions.

Sometimes attempts at peace even triggered violence. In 1840 several Comanche chiefs and their people came to San Antonio seeking peace. They were told that first they must surrender all of the white children they held captive. When they returned a month later, they brought only sixteen-year-old Matilda Lockhart, claiming the other children were with different bands.

Matilda Lockhart was in poor condition when she was surrendered, and she told a tale of abuse. She informed the whites that she had seen other white children in the camp a few days earlier. Convinced that the Comanches intended to bring in the children one at a time, the peace commissioners informed the chiefs that they would be held hostage until all children had been surrendered. The Comanches tried to fight their way out of the Council House in San Antonio, but all of the men and some of the women were killed.

The aroused Comanches raised a revenge party of several hundred warriors and headed for the settlements. They looted Victoria and burned Linnville before heading for their own country with pack horses and mules laden with booty. Whites discovered their trail and raised a large force; together with some Tonkawa warriors they met the Comanches at Plum Creek not far from Austin. In the battle, much of the loot and most of the horses were recovered.

Whites, guided by Lipan Apache scouts, followed the Comanches several hundred miles to their camp on the upper Colorado. They surprised and destroyed the camp, and for a few years the frontier was relatively peaceful.

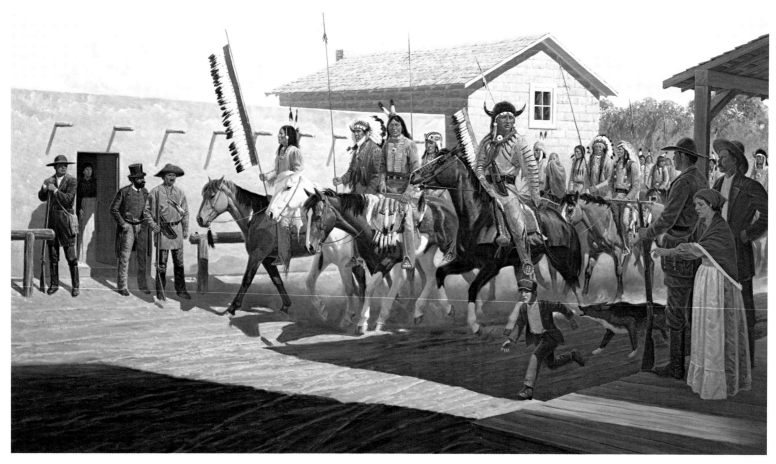

Lee Herring. *Matilda Lockhart Comes Home.*

After Texas became a state in 1846, protection of the frontier was the federal government's responsibility. Following the war with Mexico, the government assigned seven infantry companies to this task, but they were ineffective against mounted warriors. In 1849 the army built a line of military posts from Fort Worth south to the Rio Grande. In two years the rapid settlement of the frontier made it necessary to construct a new line of forts farther west. As long as the garrisons were manned mainly with infantry, however, the raiding continued.

In 1856 detachments of the Second Cavalry Regiment replaced the infantry, and they were more successful in punishing and discouraging raiders. But when part of the force was sent elsewhere, raiding parties again struck with the usual devastating effect. When Texas seceded from the Union in 1861, federal troops withdrew from the forts and were replaced by newly recruited Confederate units.

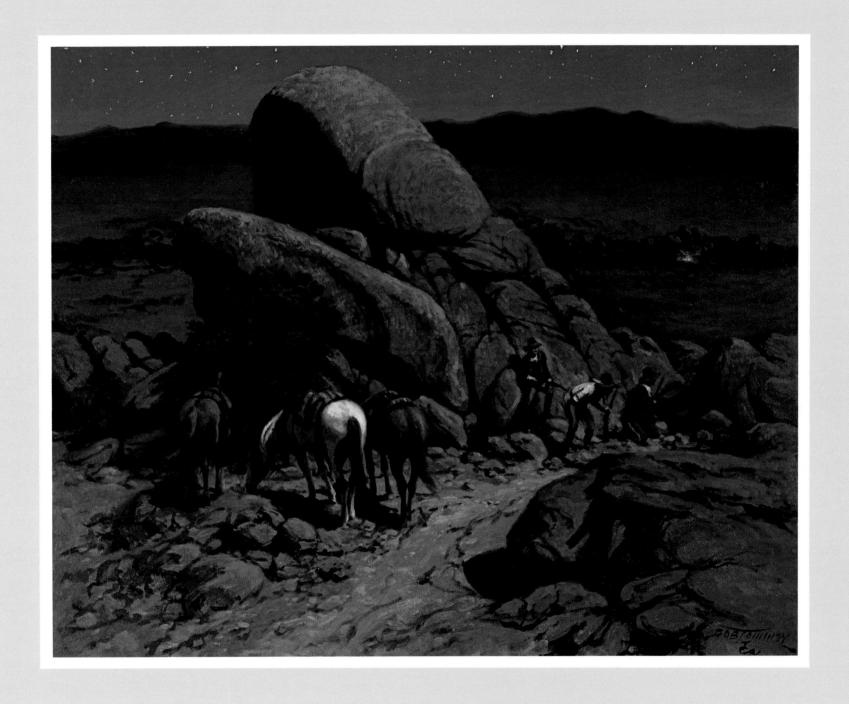

Bob Tommey. *Cavalry Night Patrol.*

During the Civil War, hundreds of ranchers and cowboys served in state or Confederate forces. Stripped of so many of its able-bodied men, the state was reduced to organizing frontier militia units of men over draft age. The militia could do little more than pursue some bands in an attempt to rescue captive women and children and to recover stolen stock. Their efforts were usually fruitless, for the raiders retreated swiftly northward, killing captives or animals that couldn't keep up. Four-fifths of the frontier ranchers abandoned their cattle and sought safety during this period. The frontier, which had moved steadily westward when defended by the U.S. Cavalry troops stationed in a long line of frontier forts, retreated even more rapidly after those troops were removed in 1861.

In the early 1870s President U. S. Grant's Peace Policy drastically curtailed the army's role in controlling Plains tribes. After the Comanches, Kiowas, and Southern Cheyennes attacked a group of buffalo hunters at Adobe Walls in the Texas Panhandle in June 1874, Grant jettisoned the Peace Policy and turned to the army to force the Indians to return to their reservations and remain there.

Five columns of troops and the new Frontier Battalion of Texas Rangers converged on the Indians' buffalo range in the Panhandle. A number of battles were fought, but the turning point came when Colonel Ranald S. Mackenzie destroyed the Indian camps and horse herds in Palo Duro Canyon in September 1874.

The disappearance of the buffalo contributed greatly to the final defeat of the Plains Indians. By the early 1870s, Pennsylvania tanners had developed a process for converting buffalo hides into good leather, and a great demand arose for the hides. Hundreds of buffalo hunters flocked to the southern Plains, and by the winter of 1878−79, few buffalo were left. Neither Indians nor hide hunters could believe that the enormous southern herd had been completely destroyed, but they searched in vain for buffalo.

Mackenzie's defeat of the southern Plains tribes in 1874 and the ensuing slaughter of the buffalo ended danger from Indians in West Texas. As Frank Collinson observed, "Like buzzards waiting for an old cow to die in a boghole, hundreds of cowmen had been waiting to grab the wonderful ranch country where the buffalo had roamed. They knew it was the finest grazing land on earth." Cowmen quickly took advantage of the last large area of open range and free grass and moved their herds to the Panhandle.

Mavericks and Wild Cow Hunts

MAVERICK, the name for an unmarked range animal, entered the ranching vocabulary in the 1850s. Samuel Maverick, who was not a cattleman, received a herd of cows in repayment of a debt. The man Maverick left in charge of the cattle for several years failed to brand the calves. Maverick sold the herd to Toutant de Beauregard, who promptly claimed all unbranded cattle for miles around as *Maverick's*, and the name was soon applied to all unmarked range cattle. Unbranded horses were called "slicks."

According to range custom, a maverick belonged to the man who caught it and put his brand and earmark on it. There were at the time between four and six million wild Longhorns along the grassy coastal plains and in the brush country between the Nueces and the Rio Grande. Some were "mossyhorns," steers or bulls ten years old or more. They were extremely wild and when roped or cornered were as dangerous as a bear with a sore paw. The wild cattle hid in dense, thorny thickets by day and came out to graze at night.

Brush poppers caught wild cattle by pushing them into a decoy herd and then carefully driving that herd into a corral. Or, on bright moonlit nights when the wild cattle came out to graze, brush poppers roped them. Sometimes they necked wild cattle to tame oxen, which eventually got them into a corral. Building a herd by catching wild cattle in the brush country was difficult and dangerous work requiring a special group of men, primarily Mexican and Indian vaqueros on tough little mustangs.

When Texas men went off to the Civil War, their cattle were left free to roam. After the war, thousands of unmarked wild cattle roamed the brush country of South Texas. Texas, like all former Confederate states, was impoverished by the Civil War. Confederate veterans returned to face a bleak future, their money worthless, their homes and corrals often in shambles, and their cattle strayed or stolen. But unlike the others, Texans had a potential asset for fairly rapid recovery—millions of beef cattle. Discharged soldiers, often wearing the remnants of their Confederate uniforms, organized wild cow hunts to rebuild their herds. The great era of "mavericking" began.

In the East there was a large and growing demand for beef. The problem was how to get Texas cattle to eastern markets. Because Texas Longhorns carried tick fever, which wiped out herds wherever Texas cattle were introduced, Missouri and Kansas quarantined cattle from Texas in the mid-1850s. Before the war, Texas cowmen continued to get their herds to markets by avoiding settlements, but in 1866 most herds were turned back.

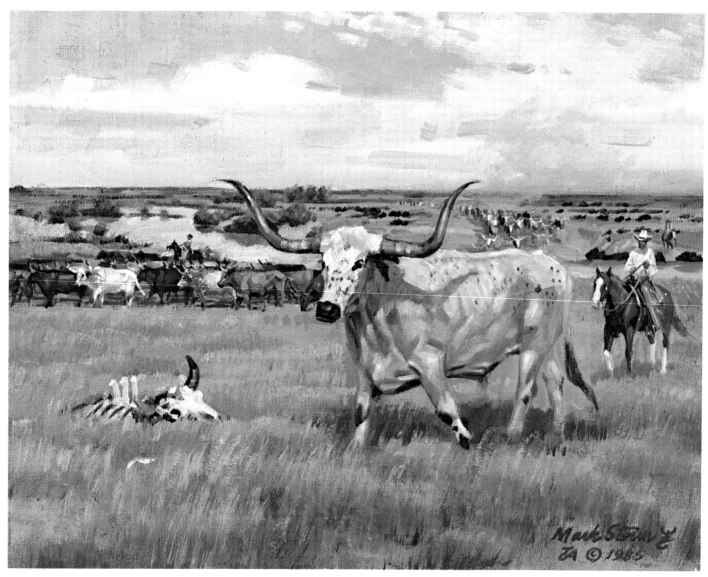

Mark Storm. *Moving West.*

By 1867, the Kansas Pacific Railroad had reached central Kansas beyond the quarantine line, and the great trailing era began. Before it ended two decades later, some eight to ten million Texas cattle had been trailed north for shipment, delivery to Indian reservations and military posts, or stocking the new ranches that sprang up as the buffalo herds vanished and the Plains warriors were confined to reservations. It was the greatest movement of cattle in history, and the millions of dollars in gold brought back to Texas helped the state recover from the economic doldrums of the Reconstruction years.

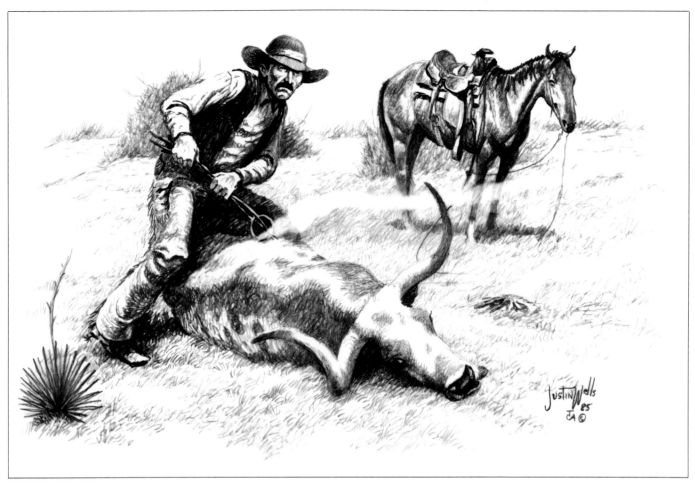

Justin Wells.
Running Iron Man.

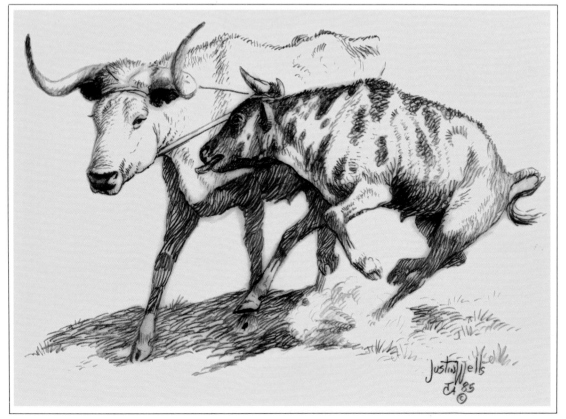

Justin Wells.
Necking the Maverick.

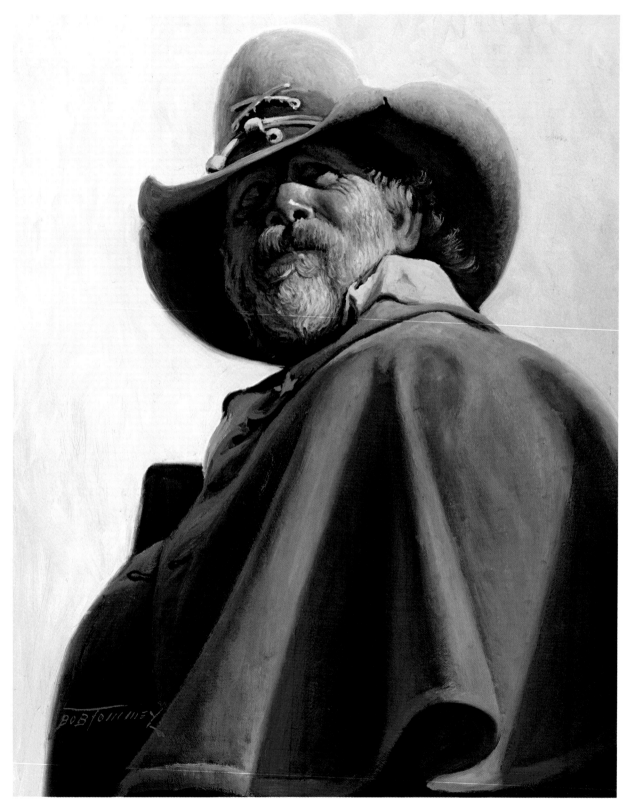

Bob Tommey.
Goin' Back to Texas.

Mark Storm. *Welcome Home.*

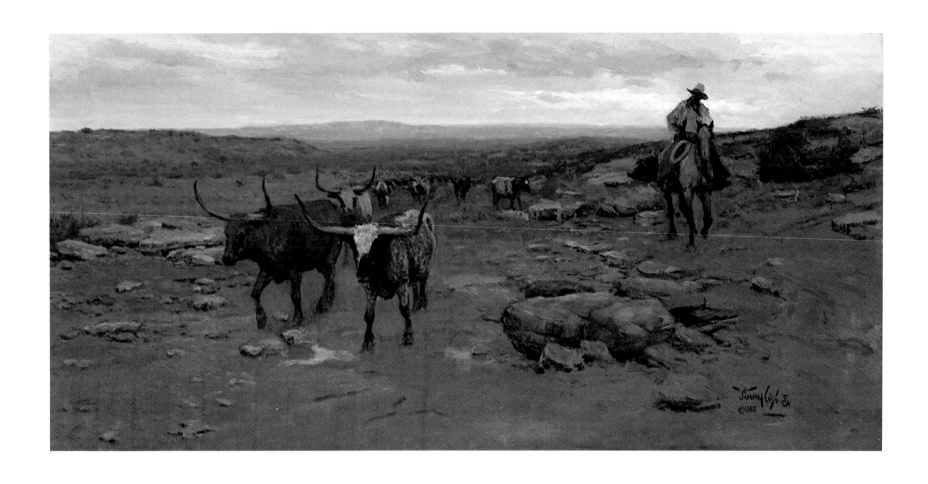

Jimmy Cox. *The Majestic Breed.*

The Long Drives of the Trailing Era

ALTHOUGH THE GREAT TRAILING ERA did not begin until the 1860s, Texas cowboys had been taking cattle overland for years. Tejano and Anglo cowmen drove small herds of steers to New Orleans as early as the 1820s and 1830s, and Texans continued selling cattle in Louisiana after the Texas Republic was born in 1836. In the mid-1840s some men began trailing herds north on the Old Shawnee Trail, which crossed the Red River at Preston and continued to Missouri.

Soon after the Gold Rush to California began in 1849, Texas cattle were on the long trail across New Mexico and Arizona to California. In 1851 a severe drouth depleted California herds, and Texas cattle brought high prices in the mining regions. Trailing cattle from Texas to California reached its peak in 1854, continued until the Civil War began, and was resumed occasionally afterward. Some of the herds were taken by way of El Paso and southern Arizona; others went by way of Santa Fe and northern Arizona. Shortly before the outbreak of the Civil War, Oliver Loving drove a herd to the vicinity of modern Pueblo, Colorado, where he wintered it before selling it in Denver.

Before the fall of Little Rock to Union forces closed the Old Government Road, Texas cowmen drove herds east to supply the Confederate Army. Oliver Loving and John Chisum were among Texas cowmen who were appointed to provide beef for Confederate forces.

When herds driven up the Shawnee Trail in 1866 were turned back at the Kansas and Missouri borders by bands of irate farmers who had watched their cattle die of tick fever, jayhawkers seized the opportunity to harass drovers, scatter herds, and steal cattle. Some herds were driven west beyond the settlements and reached markets, but few were sold profitably because of prejudice against Longhorns.

Several successful long drives in 1866 involved Texas cattle and cowboys but not Texas cowmen. Nelson Story of Montana purchased a herd in North Texas and drove it all the way to the Montana goldfields. George Duffield of Iowa bought cattle in Lampasas County and, by circling to the west of the Kansas settlements, was able to reach Iowa. Henry Spekes took a herd north to the Old Santa Fe Trail, then turned east and reached Kansas City. Texans Oliver Loving and Charles Goodnight drove the first herd west from the Fort Belknap area to the Pecos by way of modern San Angelo, crossing the river at Horsehead Crossing, once used by buffalo, Comanches and gold seekers, then following the Pecos north to Fort Sumner. This route became known as the Goodnight-Loving Trail. At Fort Sumner, they sold most of the herd for a substantial profit. Later Loving continued on from Fort Sumner to Colorado with herds of Texas cattle.

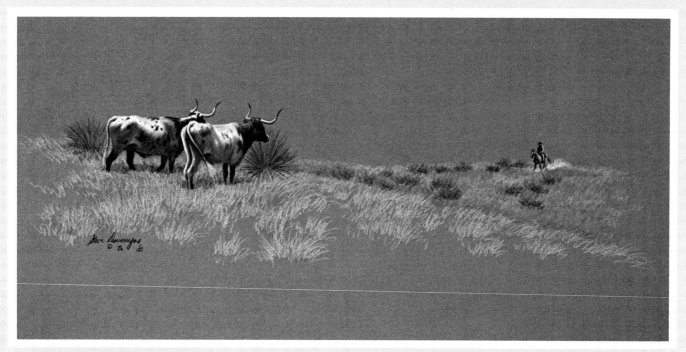

Steve Devenyns. *Wild and Free.*

Steve Devenyns. *Starting the Gather.*

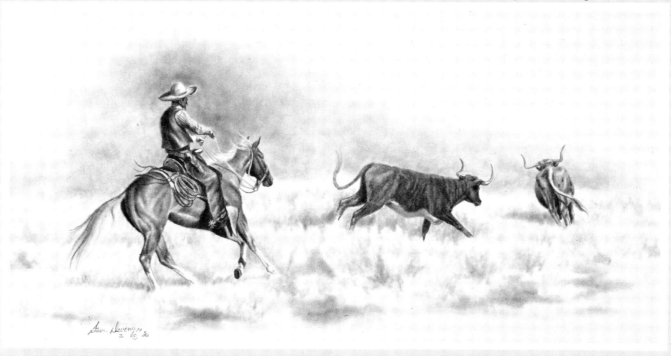

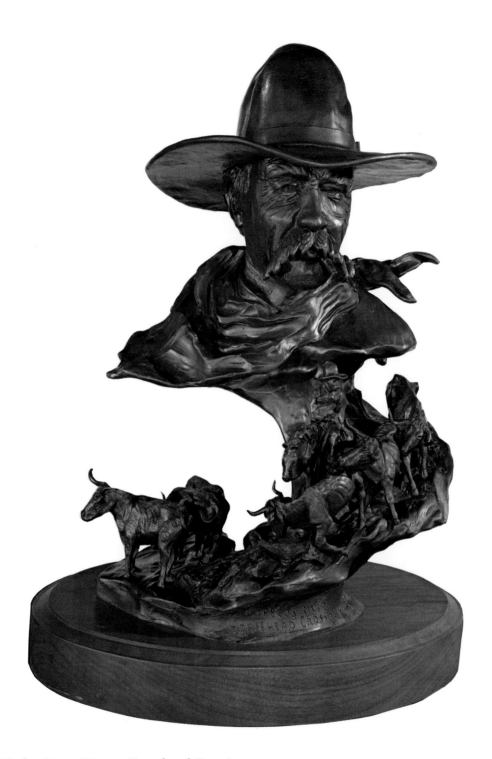

Garland Weeks. *Pecos River—Horsehead Crossing.*

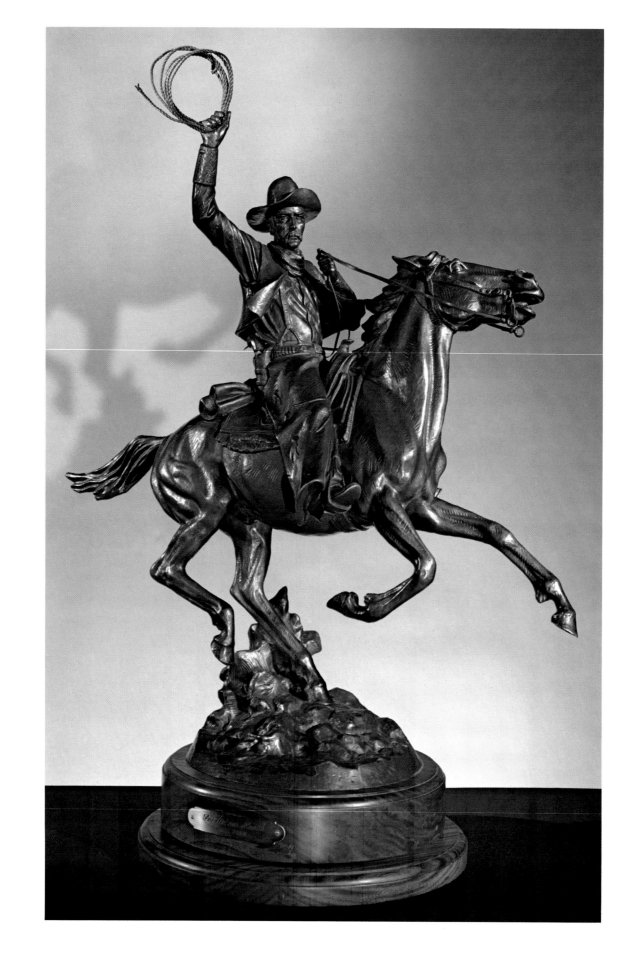

The Old Chisholm Trail—
The Most Famous of All

THE MOST FAMOUS CATTLE TRAIL was named for Jesse Chisholm, a trader of Scottish and Cherokee descent. For several years, he hauled goods in wagons from his post near the site of modern Wichita two hundred twenty miles south to Comanche and Kiowa camps in Indian Territory.

When the cattle herds came up from Texas in 1867, they followed Jesse Chisholm's wagon tracks from the crossing on the Cimarron River (now Dover, Oklahoma) to near the present site of Wichita, Kansas, passing west of this location to go north to Abilene. Cattlemen used about one hundred fifty miles of Chisholm's trail but, in return, named the entire distance from the Rio Grande to central Kansas the Chisholm Trail.

The trail extended some eight hundred miles, from Texas to Kansas. Dozens of feeder trails from the various cattle ranges of South and Central Texas joined the main trail. Some men considered the feeder trail they used part of the Chisholm Trail, which caused some confusion as to its actual starting point.

When there were many herds heading for Kansas, they might spread out for ten or fifteen miles on either side of the trail in order to find grass. The herds converged at towns such as Fort Worth and at river crossings.

The trail was used from 1867 until the middle of the 1880s, by which time the spread of farms had made it almost impossible for Texas herds to reach most shipping points on the trail. The Western Trail, which turned off the Chisholm near Belton, became the major route for Texas herds. It ran west of the older trail past Fort Griffin, crossing the Red River at Doan's Store and heading north to Dodge City, the Cowboy Capital.

Today, the marks of the old Chisholm Trail are still visible at some points along the route. They can be seen near the Kansas-Oklahoma state line, at the crossing of Pond Creek, Oklahoma, and south of Hennessey, Oklahoma, along Highway 81.

Terrell O'Brien. *Pointin' 'Em North.*

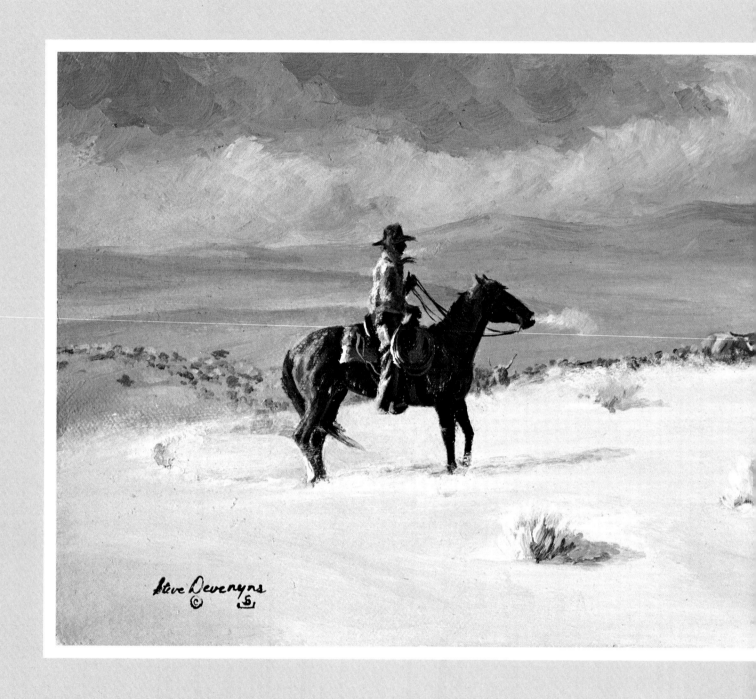

Steve Devenyns. *Spring in Cheyenne.*

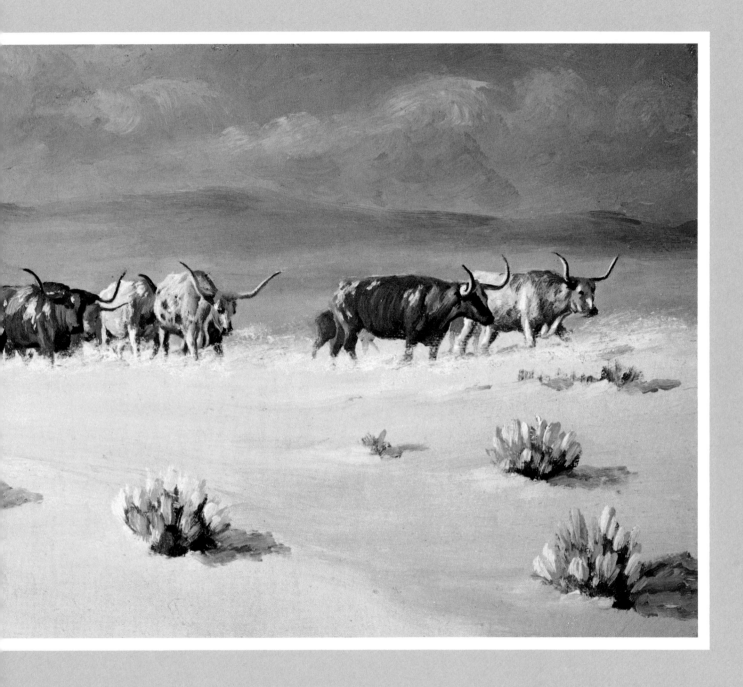

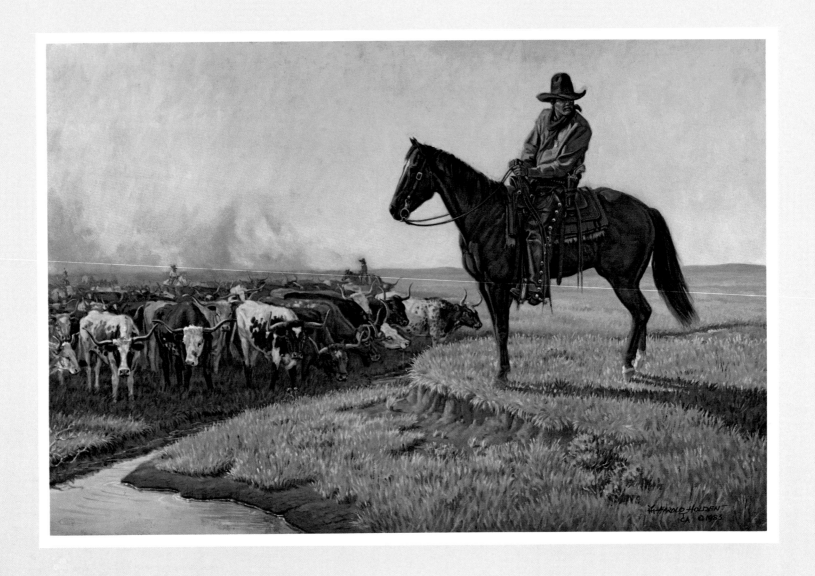

Harold Holden. *Buffalo Springs on the Chisholm Trail.*

On the Trail

OVER THE YEARS, trailing techniques were perfected. At first the "crowd" or trail crew was large. O. O. Wheeler and his partners hired fifty-four men to move twenty-five hundred steers in 1867, partly to protect the herd against Indians. Once danger from Indians declined it was found that a trail boss, a cook, a wrangler for the remuda of spare horses, and ten cowboys could move a herd of twenty-five hundred or three thousand cattle for three months at a cost of about seventy-five cents a head. This was not only cheaper than shipping by rail, but the cattle generally arrived in better condition when trailed. The herds were not actually driven, but were allowed to graze along, making ten or twelve miles a day.

On the trail the boss rode ahead each morning to check on grass and water and to select a place to stop at noon and a bedground for night. The two most experienced cowboys, the "point" men or pointers, rode on opposite sides of the lead steers. Next down the line were the "swing" men, and beyond them pairs of "flank" men or flankers. Bringing up the rear, always in a thick cloud of dust, were the "drag" riders, the least experienced of the crew.

The success of any trail drive depended, above all, on the skill and knowledge of the trail boss, for he was in command. Crossing swollen rivers was one serious hazard; stampedes were another; in both cattle might be lost or injured. Finding grass and water was vital for keeping the cattle in good condition. Watering a herd properly also required skill. The herd was strung out and the lead steers were allowed to drink first. The next bunch was watered just above them, and so on until all the cattle were able to drink clear water. The trail bosses' slogan was, "Look out for the cows' feet and horses' backs and let the cook and the cowboys take care of themselves."

Next in importance to the trail boss was the cook, for even under the worst conditions he could keep up morale by providing hot and reasonably tasty food. Cooks prided themselves on their reputations for crankiness as well as for good food. They arose in the dark each morning and had breakfast ready by dawn, drove a team, kept the wagon in repair, and always had food ready at the proper times. The cook was also doctor and nurse for the injured or ailing.

In the early days a two-wheeled ox cart carried food and bedding, and conditions were exceedingly primitive. Charles Goodnight has been credited with perfecting the chuck wagon, which had a cabinet for condiments and a door that was let down to serve as a cook table. Later a *hoodlum wagon* was added to carry bedding and gear,

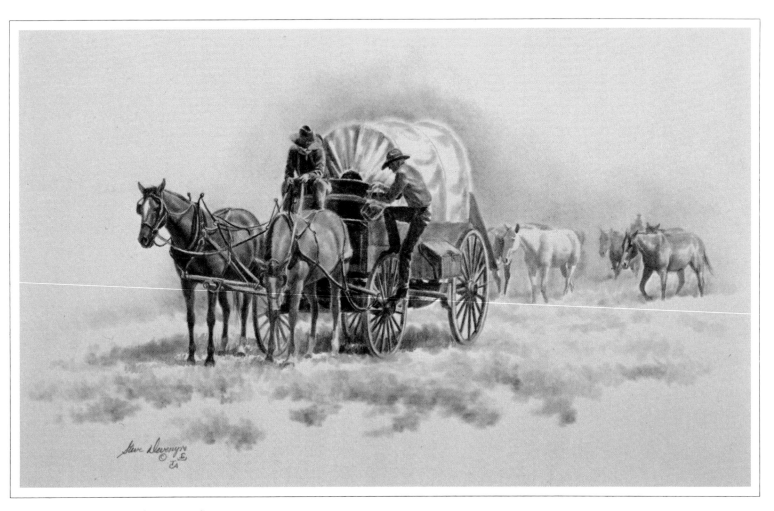

Steve Devenyns. *Cowboy's Kitchen.*

which left more room in the chuck wagon for canned food and similar delicacies. For cowboys on the trail the chuck wagon was home.

The lowest-ranking member of the crowd was the wrangler, usually a youth who aspired to be a cowboy. He was responsible for the remuda of extra cow ponies. In the early trailing days the animals were hobbled and turned loose at night to graze. Before dawn the wrangler gathered them and removed the rawhide hobbles, which he fastened around the horses' necks. By the time the men had eaten breakfast, the wrangler had the remuda in a rope corral so the cowhands could turn their night horses loose and catch fresh mounts. A good trail boss could look over a remuda of a hundred cow ponies and name any that were missing. Before a drive or roundup started, the horses were trained

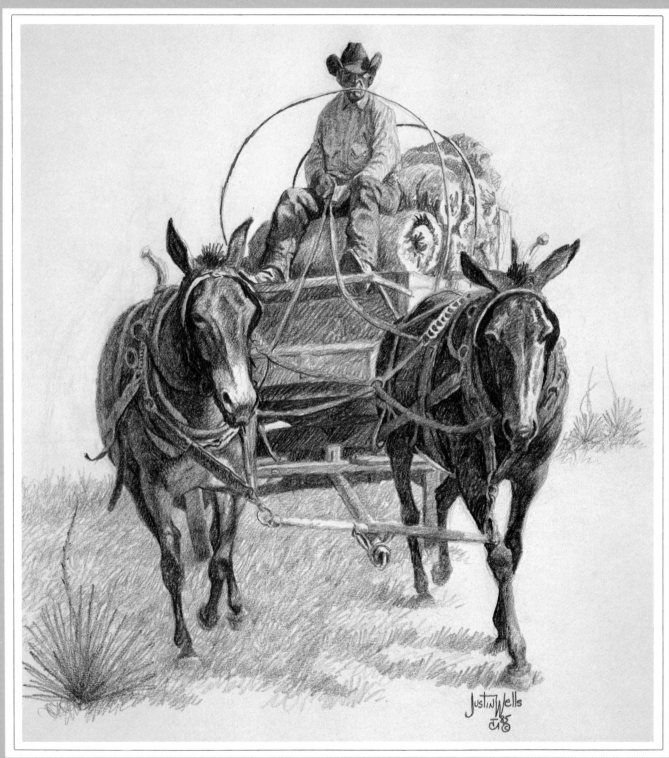

Justin Wells. *The Hoodlum Wagon.*

to respect the rope corral. To save time on the trail, whenever the men changed mounts one or two of the best ropers caught all of the horses. Each cowboy handed the roper his lariat and named the cow pony he wanted.

Eventually most crews included a nighthawk, another youth who herded the remuda all night and drove the hoodlum wagon by day, catching what sleep he could at noon and when the wagons reached the bedground several hours ahead of the cattle.

When the cattle were bedded down, night herding began. Two riders circled the herd in opposite directions for two hours at a time. Since the night herders rode the same hours every night, most automatically awakened when it was time to go on guard, and all learned to tell time by the Big Dipper. When everything went well the men got about four hours sleep each night. If the weather turned bad and the cattle were restless they might be in the saddle all night. In the morning they ate breakfast, changed horses, and started the day's drive. Lack of sleep was the main complaint of trail drivers. Unsympathetic trail bosses informed them that they could do their sleeping in the winter.

Thousands of youthful cowboys herded cattle up one or more of the trails from Texas; about one-third of them were blacks or Mexican Americans. "Going up the trail" and "seeing the elephant" were ambitions of many youths from farms and cities all over this country and Britain. The trail was a training ground for cowboys, for at the height of the trailing business there weren't enough experienced men available. Trailing cattle was not nearly as hard as regular ranch work and roundups, because once a herd was accustomed to the trail the work was largely routine.

With the routine came boredom. Youthful cowboys fought boredom by thinking about the celebrating they would do at the end of the drive. During the trailing season gamblers, saloon men, and "soiled doves" flocked to trail towns such as Abilene, Ellsworth, Wichita, and Dodge City for the purpose of relieving the carefree cowboys of their pay.

Texas cowboys regarded everyone in the trail towns as Yankees and held themselves to be superior. Most of them were inexperienced country boys, easily fleeced by card sharks and confidence men. With three months' pay in their pockets they felt powerful and prodigal. They bought watered drinks for the dance hall girls, talked loudly, and whooped and hollered. After a few days in town most had nothing to show for their work except new clothes and hangovers. One youth, the morning after a night of celebrating, tried to figure out where his money had gone. He remembered or his friends reminded him that he had bought a round of drinks in two bars, but that didn't account for all of it. "I must have spent the rest of it foolishly," he concluded.

Not all of those who went up the trail were cowboys. Lizzie Johnson Williams, who had her own ranch and brand, followed her cattle to Kansas between 1879 and 1889. Her husband, Hezekiah, had his own steers on the trail at the same time, but these were separate operations. Lizzie's only concession was to allow him to ride in her buggy. Amanda Burks, Mary Taylor Bunton, and other ranchers' wives occasionally accompanied their husbands' herds to Kansas or elsewhere.

Garland Weeks.
The Sourdough's Masterpiece.

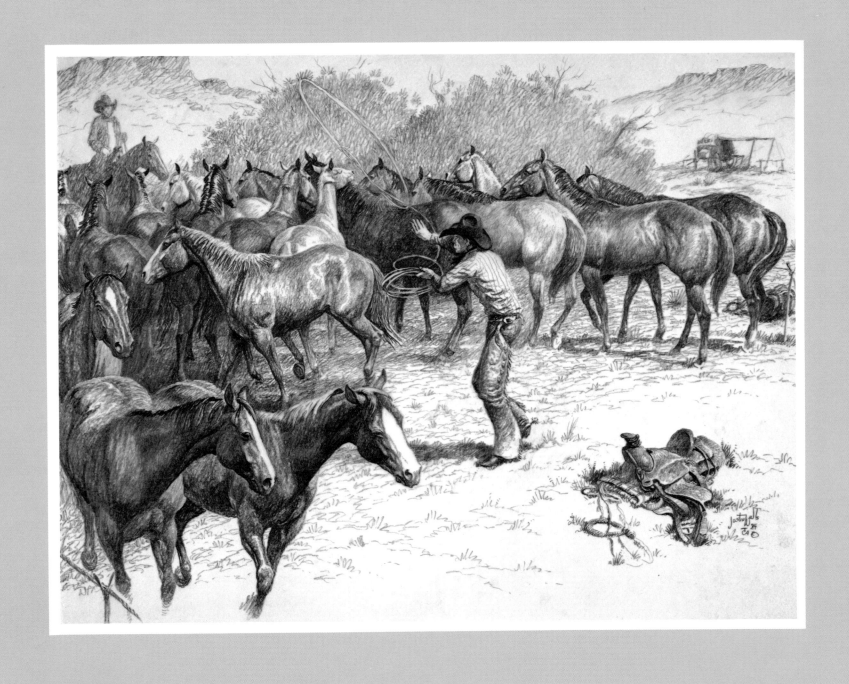

Justin Wells. *Changing Mounts.*

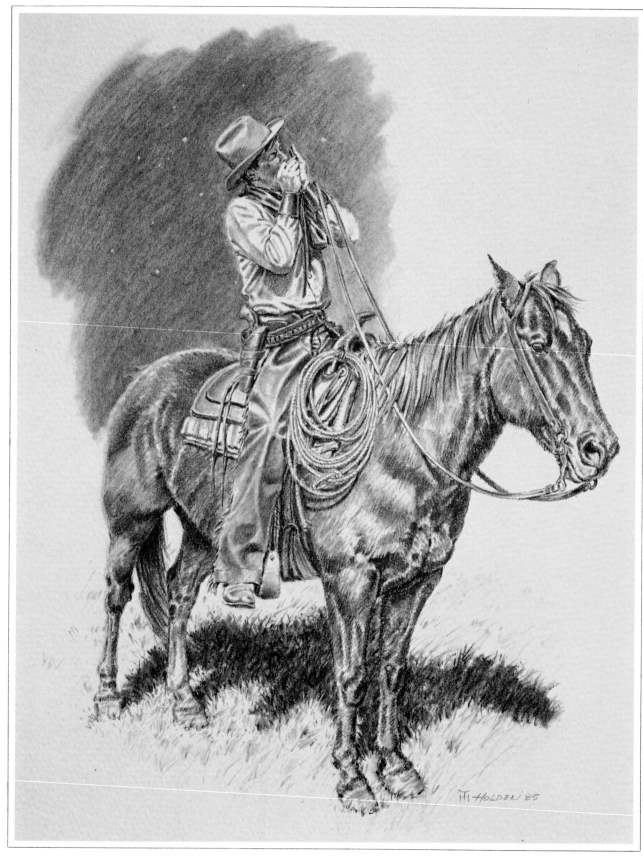

Harold Holden.
The Harmonizer.

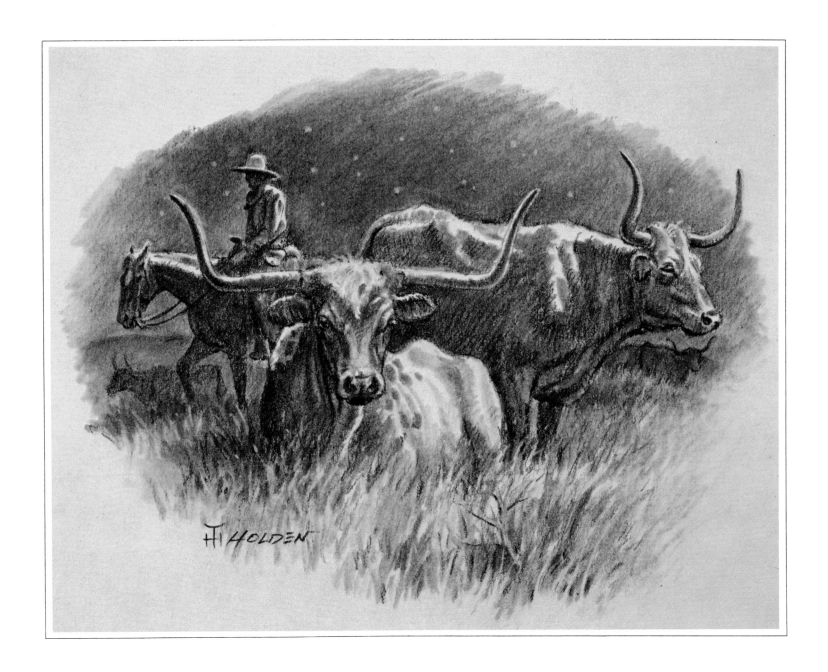

Harold Holden. *Nighthawk.*

Jim Ward.
The Trail Boss.

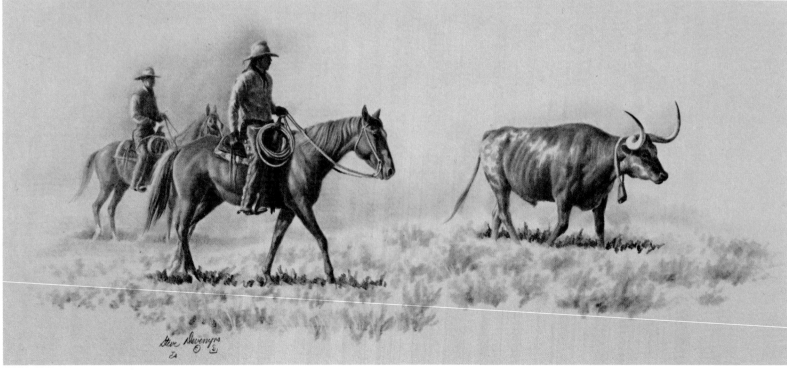

Steve Devenyns. *Trailin' Old Blue.*

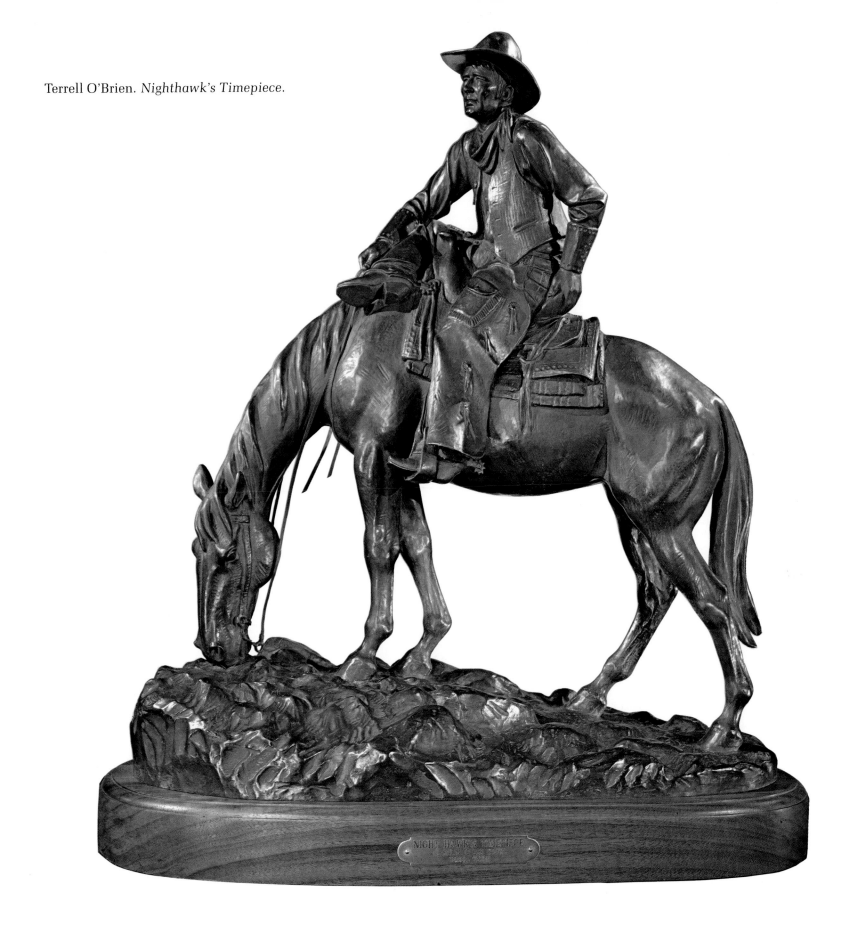

Terrell O'Brien. *Nighthawk's Timepiece.*

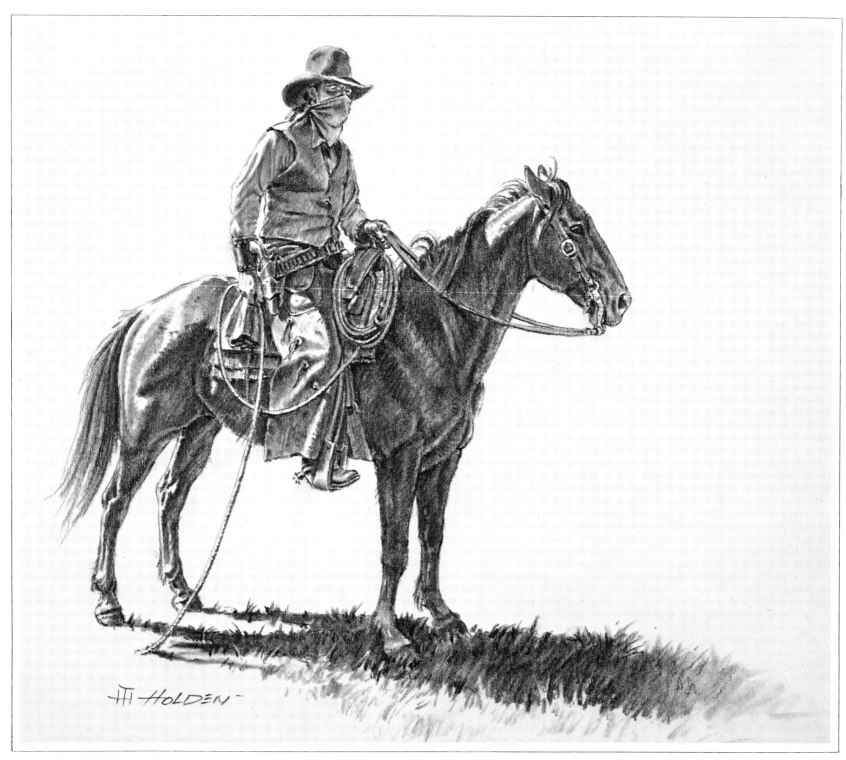

Harold Holden. *Drag.*

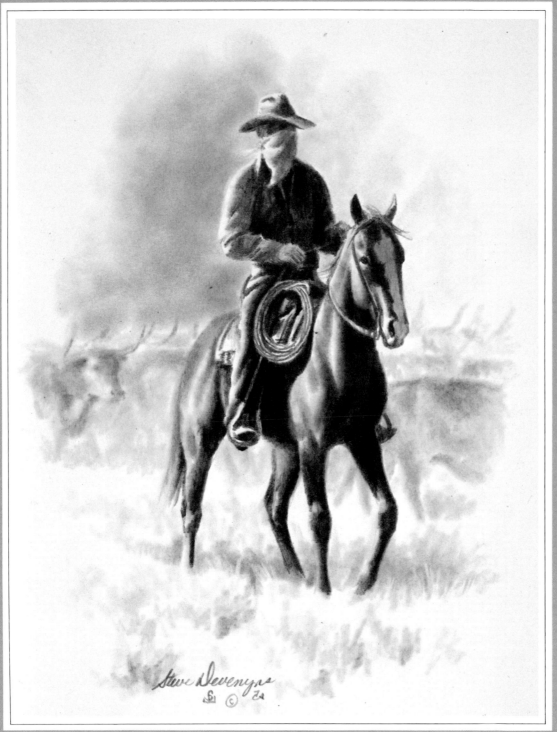

Steve Devenyns. *Eatin' Dust.*

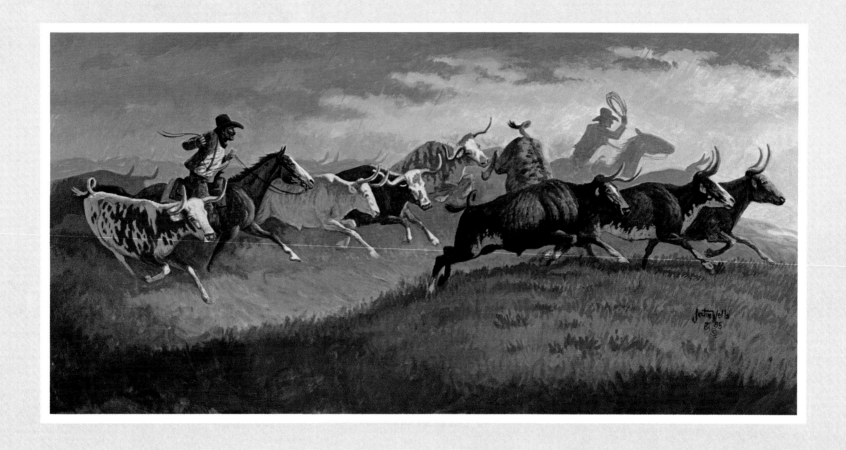

Justin Wells. *Stampede.*

Storms and Stampedes

ONE OF THE HAZARDS of the cattle trail was the stampede. Electrical storms caused most stampedes, but if the cattle were nervous, anything could start them running. One stampede occurred when a steer caught its hoof in an empty tomato can. Careless night herders caused many. One young cowboy, out of boredom, decided to see how close he could ride to a cow that had bedded down away from the others. He was finally close enough to touch her with his boot, and the stampede was on.

Some steers were chronic stampede starters and caused frequent runs. Experienced trail bosses were able to ride through a herd after it had settled down for the night and pick out troublemakers. When such steers were shot or given to Indians there was usually no more trouble, although herds might get in the habit of running every night.

Few stampedes occurred during the day, but a young drag rider started one. There was an ox with the herd, and the drag rider had trouble keeping it from lagging far behind the others. He discovered that if he hit it with his slicker it kept moving, but his slicker got caught on the animal's tail. The ox charged among the others, waving the slicker on its tail, and scared the herd into a stampede. Fortunately for the drag rider his slicker fell off and he recovered it. None of the others could figure out what caused the run, and he didn't tell them.

Stampeding steers always turned a little to the right, so cowboys rode on the left and tried to force the leaders to circle back and start the herd milling. If they were successful, the herd stopped running. The cattle were never taken back to the same bedground, for they were likely to run again.

When a thunderstorm stampeded a herd the cattle might run for miles and become scattered. If lightning struck near a running herd there was a momentary silence as all of the steers leaped into the air at once. When they came down the earth trembled. Cowboys never forgot the awesome sound of a stampeding herd of Longhorns—a wild mixture of thundering hoofs and clashing horns.

In stampedes steers were often crippled or killed and some might run so far they couldn't be found. All lost weight. A cowboy was in danger, too, and his life depended on the acute senses of his night horse. Cowboys were occasionally injured, trampled to death, killed by falls into ravines, or struck by lightning. A few expert trail bosses left all but two or three of the most experienced hands in camp when a run started and rode until they got the cattle milling.

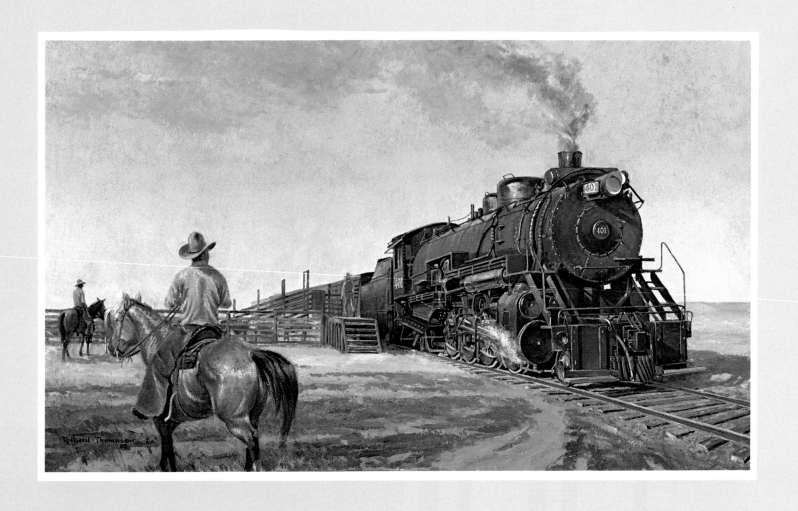

Richard Thompson. *Loading Cars.*

Railroads and Cattle Trails

IN THE SPRING OF 1867, Illinois cattle dealer Joseph G. McCoy made arrangements with Kansas and Pacific Railroad officials to build a siding at the hamlet of Abilene, Kansas, while he built pens and loading facilities. McCoy sent riders to Indian Territory and North Texas to inform cowmen of the new market for cattle. Although the season was late by the time his pens were ready, McCoy shipped 35,000 head in a month or two.

Abilene was the first post-war trail town in central Kansas, but in 1871 the people of the community, no longer willing to put up with the gamblers, soiled doves, and boisterous cowboys, told Texans to take their cattle elsewhere. Ellsworth became the next major shipping point on the Kansas and Pacific line, but in 1872 the Santa Fe Railroad tracks reached Newton, and that railroad began competing for the cattle-hauling business. In 1873 the Wichita and Southwestern, a Santa Fe subsidiary, was extended to Wichita. For several years that town was the main destination for cattle coming up the Chisholm Trail.

Dodge City, reached by the Santa Fe in 1872, was the main shipping center for buffalo hides for several years. But from 1875 to 1886, Dodge City flourished as the Cowboy Capital as Texas herds by the hundreds came up the Western Trail. The last shipping point on the old Chisholm Trail was Caldwell, The Border Queen, in southern Kansas.

When cattle were to be shipped from any railroad loading facility, the company had the necessary number of cattle cars ready on a siding. One cowboy remembered the loading chutes vividly: "If we were able to pole the cars into position, we would load the cattle without the help of the engine, which was always late in arriving. But if there were too many cars to move by hand, we would wait for the engine to arrive." Once in Vega, Texas, the engineer let steam off the engine as it came to a halt at the pens. The terrified steers flattened the loading corrals and scattered to the four winds.

In loading cattle, men armed with long poles prodded the cattle to keep them moving up the loading chutes and into the cars. When the train stopped, they also prodded any animal that was lying down, for it was likely to be injured. "Cowpuncher," a term rarely used in Texas, apparently arose as a result of this practice. Cowpuncher became synonymous with cowboy in some regions, and "punching cows" came to mean working cattle on the range.

Refrigerated cars were available by 1876 when the Atlantic and Texas Refrigerated Car Company opened a packing plant in Denison. Each car carried twice as many carcasses as a cattle car held live animals. In 1876, the Texas and Pacific Railroad reached Fort Worth, and a year later the first carload of refrigerated beef was shipped from Fort Worth to St. Louis. That same year, the Texas and Pacific also shipped fifty-one thousand live cattle from Fort Worth, but it was still cheaper to trail cattle north than to ship them. A few years later, the Missouri, Kansas and Texas Railroad and the Santa Fe also reached Fort Worth, making it an important rail center for the beef cattle industry.

After the trails were closed by barbed wire and quarantines, the railroads competed for the cattle-hauling business by lowering freight rates. Big ranches such as the Matador that leased fattening ranges in Montana usually trailed young steers wherever possible and shipped them the rest of the way. This practice continued into the mid-1890s.

Railroads continued to haul cattle to market until the middle decades of the twentieth century. Since many ranches were a hundred miles or more from the nearest railroad, cattle still had to be trailed relatively short distances for shipping. The development of huge trucks and double-decked stock trailers ended shipment by rail, for the trucks could move stock from home ranges to any place in the country.

Open-Range Ranching

WHEN THE TRAILING ERA began and Texas Longhorns were valuable for the first time, many men started ranching. All that was necessary was to find an unoccupied range, acquire some land for a house, corrals, and horse pasture, and register a brand. Many men got their start by mavericking after the Civil War when the thousands of unbranded cattle which roamed the Texas ranges belonged to the man who put his mark on them. There was still danger from Kiowas and Comanches, who killed cowboys and ran off cattle to trade to the Comancheros of New Mexico.

By 1875 the Indians were confined to reservations, and in the next few years the last of the buffalo were gone from the plains. In the late 1870s and early 1880s there was a rapid expansion of cattle raising on the vast grassland that was previously the domain of Indian warriors and buffalo.

The open range that stretched from the Rio Grande to the Canadian border invited an unprecedented boom in cattle ranching, attracting investors from Europe and the British Isles as well as from the eastern United States. Some men, such as Irish financier John Adair, formed partnerships with Texas cowmen. Charles Goodnight and Adair joined forces to establish the JA Ranch in Palo Duro Canyon in 1876.

Domestic and foreign syndicates were also established to raise money to start ranches on unoccupied rangeland. General James S. Brisbin's *The Beef Bonanza; or, How to Get Rich on the Plains* was a potent factor in the cattle boom, for he asserted that with free grass it cost only ten dollars or less to buy and raise a three-year-old steer worth thirty dollars, and he gave examples of men who had made substantial profits. For most of the eager investors, however, such profits failed to materialize.

Among the British-owned syndicates were the Prairie Land and Cattle Company and the Matador, both organized in Scotland. The XIT Ranch belonged to the Capitol Syndicate of Chicago, which was created to build the Texas statehouse in exchange for three million acres in the Panhandle. The Matador and the XIT were two of the most successful syndicate ranches.

One reason that few of the syndicate ranches were profitable was that the coming of barbed wire and of homesteaders made it necessary to buy and fence the range, often doubling the investment. There was still free grass for many years in some places, but it was over-grazed and ruined. Syndicate ranches also suffered more than average losses of cattle, because both cowboys and small ranchers resented absentee owners. Further, local juries refused to find rustlers guilty when they stole from the big syndicates.

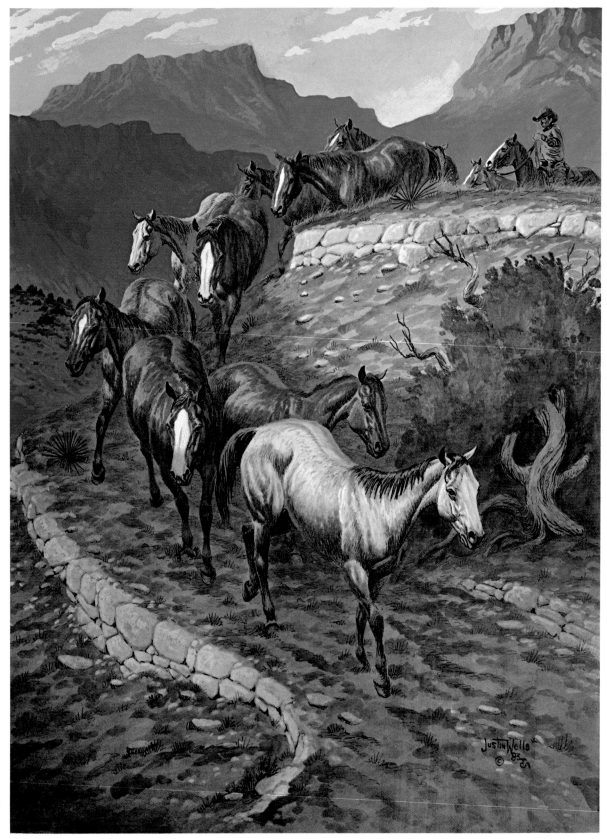

Justin Wells.
Bringing in the Remuda.

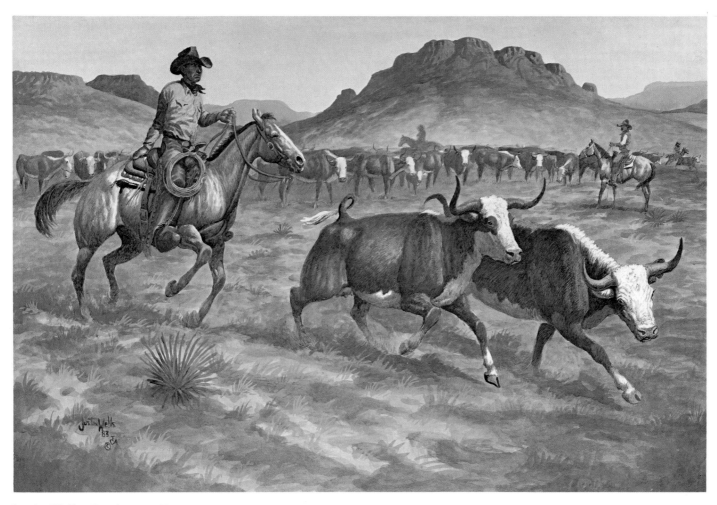

Justin Wells. *Cutting out Drys.*

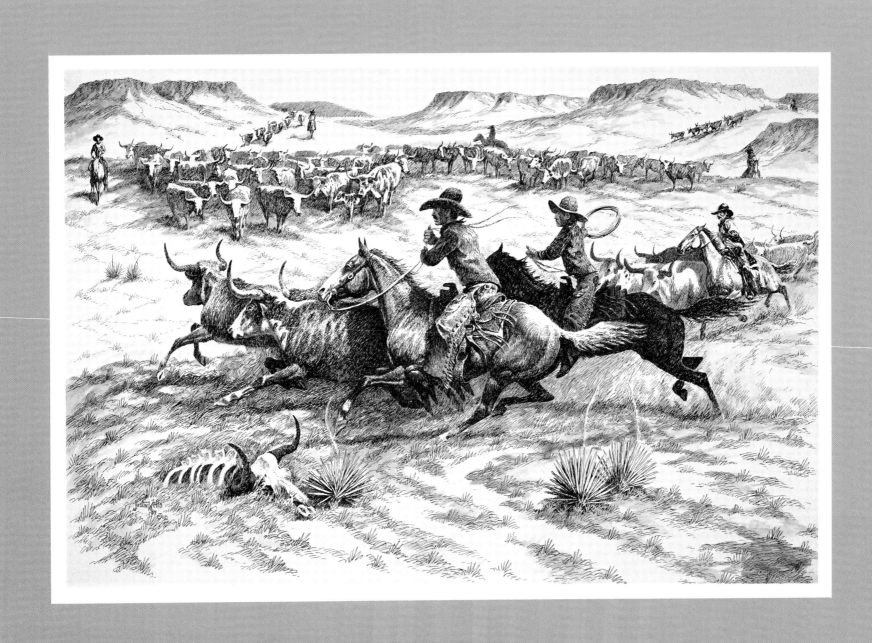

Justin Wells. *Coming off Circle.*

Roundups on the Big Range

DURING THE DAYS of open-range ranching, big roundups were necessary because cattle, unlike horses, were always ready to leave the range where they were born and wander a hundred miles or more, especially when driven by storms out of the north. Each spring ranchers of the region sent men, horses, a cook, and a chuck wagon to cooperate with others on the cow and calf roundup. Distant ranchers sent representatives or "reps" to recover their strays.

One of the men from the ranch where the roundup began took charge until the roundup crew moved on to another range. He chose the gathering places and instructed the circle riders. These men would string out and circle the gathering ground ten or fifteen miles out, pushing all cattle toward the center. Circle riders rode "long" horses, animals that could lope for hours and cover forty or fifty miles. Often they were brutes or outlaws from the "rough string," too mean and hard-headed for ordinary cow work but tireless and useful for riding circle.

By early afternoon the cattle were gathered in one huge, bawling mass. A fire for heating branding irons was built, while the most skillful ropers circled quietly around the herd, tossing small loops over the heads of calves and dragging them to the fire. The roper called out the name of the brand on the cow. Two men grabbed the calf, removed the rope, and held it down while it was branded and, if a bull, castrated. Another ear-marked the calf before it was released. This was hot, dirty work, for a thick cloud of dust constantly hung over men and animals. When all of the calves were branded, cows and calves belonging to distant ranches were separated and the reps from those ranches drove them back to their proper ranges. The roundup crew moved on to another gathering ground. A big open-range roundup might take three months and cover a vast area.

If a cowboy saw an unbranded calf or maverick he roped it, tied its legs, and built a small fire. With a light running iron he branded it as the cow was branded. If it was a maverick not running with a cow he put his ranch's brand on it. There were also running-iron artists who altered brands on cattle in order to steal them.

In the fall the steer roundup was held to separate those ready for market: a "beef" was a steer four or more years old. On the steer roundup cowboys also branded any calves they had missed in the spring. When ranchers bought and fenced their ranges the big roundups were no longer necessary, and they gradually disappeared.

All trail herds had to be road branded, for they were usually composed of cattle

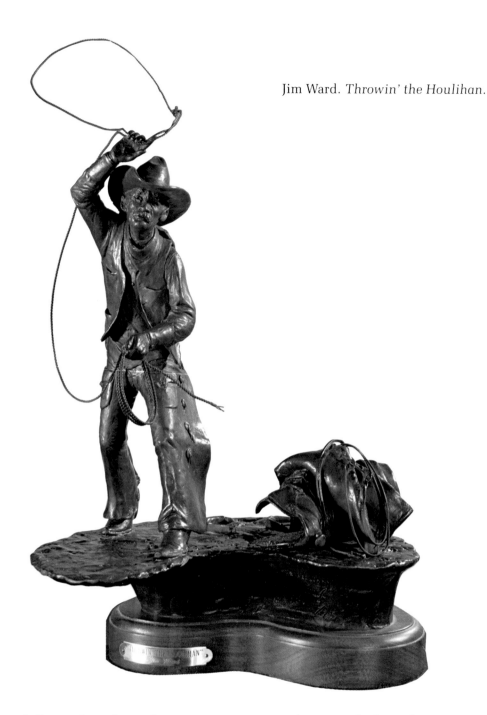

Jim Ward. *Throwin' the Houlihan.*

bearing many different brands, and it was necessary to distinguish them from strays that might join the herd. This was different from calf branding, for the herd might be of steers four years old or more. One cowboy roped the steer's head; another roped its hind legs so it could be stretched out on the ground for branding. Road branding a herd of twenty-five hundred half-wild steers was no easy task.

Later, branding chutes were built where trail herds were gathered. These chutes

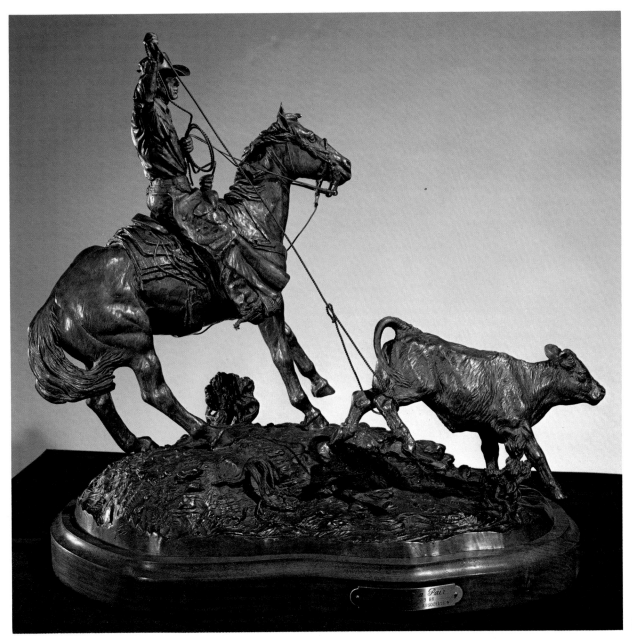

Harold Holden. *Pickin' up a Pair.*

held ten or twelve steers at a time. Steers were branded quickly and released without the necessity of roping them. Before a herd was put on the trail it was important for a brand inspector to count and record the number of animals of each brand. This list was kept at the county courthouse so cowmen could be sure they had been paid for all of their cattle taken north by others.

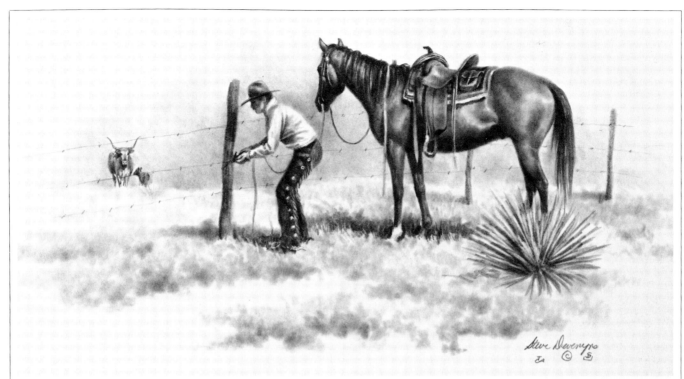

Steve Devenyns. *End of an Era.*

Steve Devenyns. *New Face of Texas.*

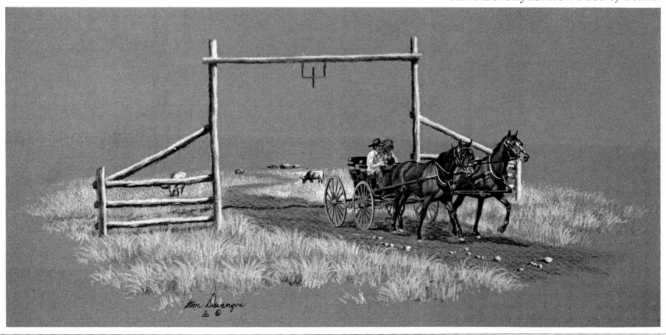

Big Ranches

THE FIRST BIG RANCHES in Texas were eighteenth-century Spanish grants and the missions of San Antonio and La Bahía (modern Goliad). The first large non-Spanish ranch to be established belonged to James Taylor White (formerly Le Blanc), who arrived from Louisiana about 1820. By the 1830s and 1840s he owned upwards of thirty thousand acres and many thousands of cattle. White, like most ranchers from the South, used slave cowboys to tend his stock.

In the 1850s Captain Richard King bought the Santa Gertrudis grant in the Nueces Strip. Over the years King and his heirs expanded the ranch until it included more than a million acres. On one occasion King bought all of the livestock in a Mexican village, then invited the families to move to his ranch. These people, and their descendants who still live and work on the ranch, proudly called themselves *Kineños*.

After the Civil War, when a steady and expanding market for Texas cattle was available, the era of the big ranches began. Because large numbers of cowboys were needed only during the spring and fall roundups, they were on their own part of each year. Many cowboys drifted from one range to another in search of work or adventure, or simply to see the elephant. Hundreds of Texas cowboys who trailed cattle to the new ranches in Wyoming or Montana stayed there, giving a Texas stamp to the whole cattle kingdom.

Texas cowboys often resented British ranch owners, absentee or otherwise. Englishman William A. Baillie-Grohman warned his countrymen to treat cowboys with tact. "A man out West is a man," he wrote, "and let him be the poorest cowboy he will assert his right of perfect equality with the best of the land, betraying a stubbornness it is vain and unwise to combat." Cowboys on the Goodnight-Adair ranch in Palo Duro Canyon greatly resented Irish financier John Adair. Once when he brusquely ordered cowboys to saddle a horse for him, they chose the worst outlaw or pitching horse on the ranch. The bronc, sensing that his rider was no cowboy when Adair waddled into the saddle, trotted meekly off. The cowboys never forgave him.

The cowboys on the big ranches were mainly Anglos, but there were usually a few blacks and Tejanos whose exceptional skills at riding and roping made them valuable hands. One black cowboy was regarded as the best rider and roper in all of West Texas. When "Nigger Ad," as he was known, married, ranchers from all over the region sent him wedding presents, among them more than twenty cookstoves.

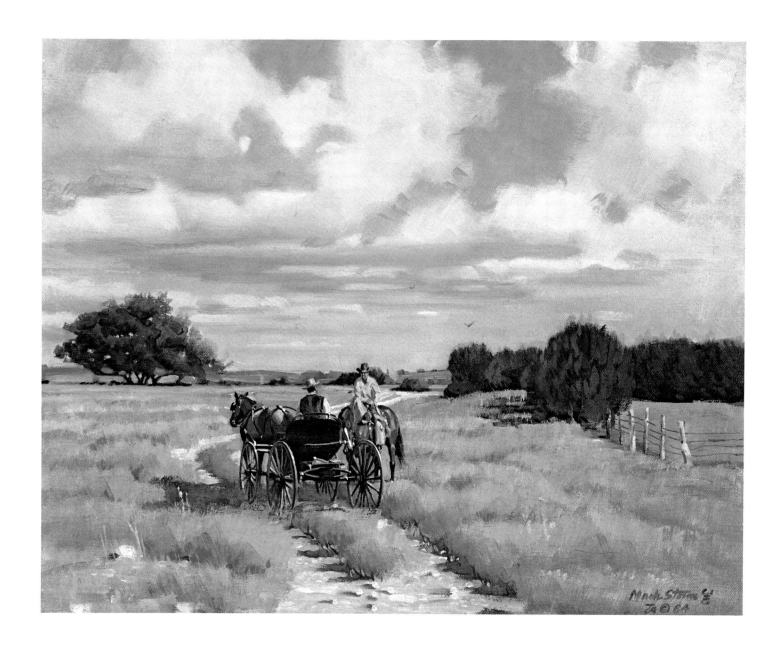

Mark Storm. *Board Meeting.*

The Big Steal and Livestock Associations

AFTER THE TRAILING ERA OPENED, Texas cattle were valuable for the first time and large-scale stealing began. Organized bands of cow thieves, among them many ex-buffalo hunters, ran off herd after herd to sell outside the state. Northwest Texas cowmen were particularly hard hit. Cattle stealing, once rare, was made a felony in 1873.

Some cowmen lost so many cattle they sold whatever was left and gave up. Others were determined to fight back, among them Colonel C. L. "Kit" Carter and C. C. Slaughter. After talking over the problem with Carter, Slaughter invited neighboring cowmen to his Palo Pinto County ranch in the fall of 1876. At this meeting they decided that Jim Loving should write to all ranchmen of Northwest Texas urging them to come to Graham in mid-February to organize for their mutual protection. Loving also sent announcements of the meeting to county newspapers.

On February 15, 1877 between sixty-five and seventy ranchers arrived at the Graham House from all directions, some coming as far as one hundred miles. According to legend they assembled under a post oak tree, but some men remembered later that they had met in Jim Smith's gun shop or a saloon, and the association itself thanked the county government for allowing it to use the courtroom.

The Stock Raisers' Association of Northwest Texas was born that day. Colonel Carter was elected president and Jim Loving, secretary. Every member was to watch for the cattle of other members in herds passing through or leaving his district. The association made rules and set dates for roundups. No one was to kill any animal not his own—for Texas cowmen this meant that for the first time they would have to eat their own beef. In 1879 the association began offering rewards for the arrest and conviction of anyone stealing cattle or horses belonging to members. At first the headquarters were in Jim Loving's home at Jermyn in Jack County, but in 1884 he moved his office to Jacksboro.

The "Big Steal" continued unabated. In 1883, when the price of cattle rose, cattle stealing became epidemic. Every member lost cattle and horses. The association increased its reward from fifty dollars to two hundred fifty dollars and appointed five men as a committee to hire inspectors to watch all shipping points, trail herds, and stockyards. Most of these men were deputized by local sheriffs.

In 1883, the fence-cutting war also broke out. Many ranchers, accustomed to the open range and free grass, greatly resented the use of barbed wire. Some even asked the

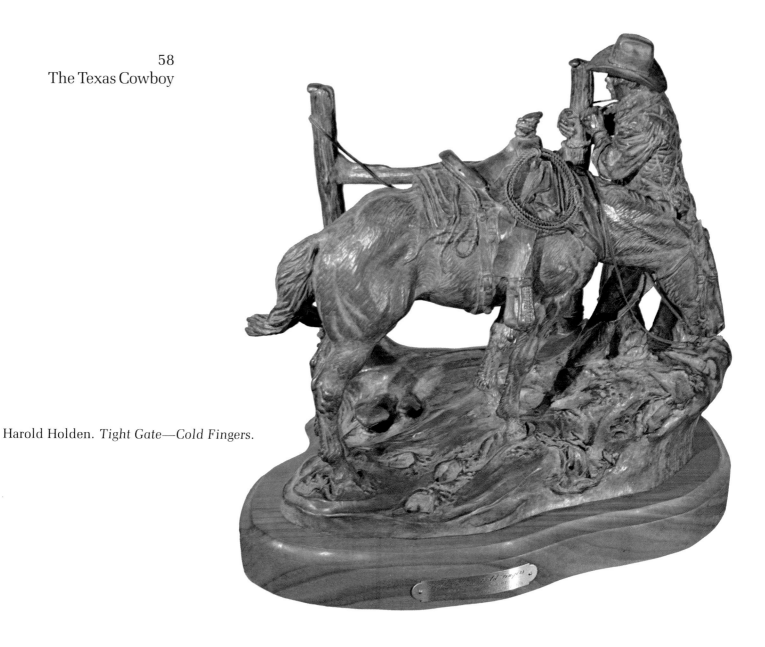

Harold Holden. *Tight Gate—Cold Fingers.*

legislature to prohibit its use, and one called it the ''curse of West Texas.'' The advantages of having fenced pastures were obvious to big ranchers, for fencing reduced the opportunities for theft, prevented cattle from straying, and made controlled breeding possible. But some big ranchers fenced in state land without leasing it and ran fences across public roads without putting in gates.

In the summer of 1883, a severe drouth forced many open-range cowmen to move their stock in search of grass and water. They were outraged when they found the way blocked by fences. The Fence War resulted. Bands of men, usually small ranchers and

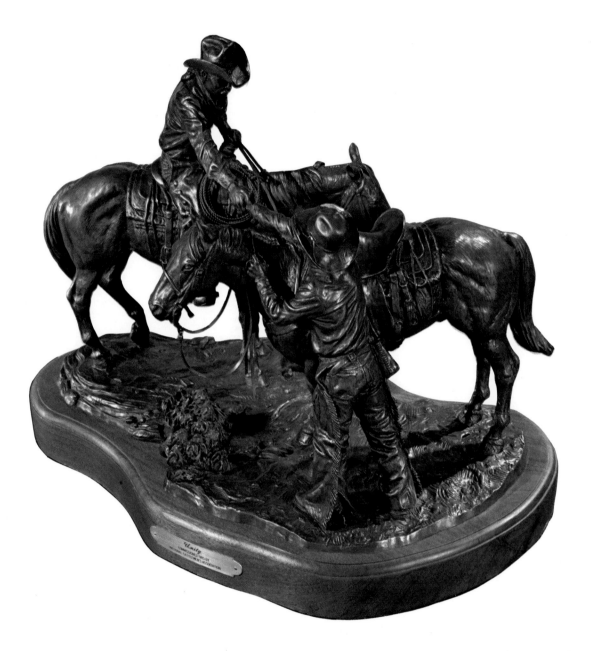

Harold Holden. *Unity*.

their cowboys, rode out at night and cut mile after mile of barbed wire. Rustlers took advantage of the conflict to cut fences and steal cattle. Before the fence-cutting war was over, property estimated at twenty million dollars had been destroyed and many lives had been lost. The situation became so desperate that investors elsewhere avoided risking their money in Texas.

At a meeting in Jacksboro in November 1884, Huntsville lawyer Colonel Tom Ball spoke to the members about the crisis. He pointed out that the end of open range and free grass was coming soon and suggested that they buy land and fence it. The associa-

tion resolved that the legislature should pass a law protecting property rights for all taxed land whether it was used for agriculture or grazing. It should also outlaw wire cutting and provide for public access to all roads.

Governor John Ireland called a special session of the legislature in December, and in January 1885 it made fence cutting a felony. It also outlawed the enclosing of land not owned or leased and required fence builders to put in gates every three miles and at all public roads. The association had shown the effectiveness of banding together for cattlemen.

A national convention of stock growers was held in St. Louis in November 1884 to promote the livestock industry. Many Texans made plans to attend. The old-time cowmen and their wives and daughters enjoyed the hoopla, but the men weren't distracted by it. They were there on business. Those who had recently invested in ranches and cattle thrilled at the chance to rub shoulders with semi-legendary figures such as Charlie Goodnight, Shanghai Pierce, and Captain Richard King, and they gloried in the title of "cattle baron."

Seventy-seven livestock associations were represented, and upwards of thirteen hundred delegates attended. Their appearance and daily activities were described in detail in the press. The old-time cowmen were an impressive sight in their wide-brimmed white hats and long black frock coats. Reporters called them members of the most outstanding new industry in America, pointing out that they represented more capital than needed to pay off the national debt.

Judge Joseph A. Carroll of Denton, Texas called for the laying out of a national cattle trail from the Red River to the Canadian border. Northern ranchers, knowing that their ranges were already well-stocked, wanted no more competition from Texas. When Carroll remarked that there must be a trail "from the breeding range in Texas to the maturing pastures of the North," Montana ranchers bristled. They pointed out that there were plenty of breeding ranges in the north. The national cattle trail went down to defeat.

It was true that calf crops were better in Texas and that steers fattened faster on the northern grasses than on those of Texas. The Matador and other large ranches leased land in Montana and trailed young steers there to fatten for a year or two, but there were also breeding herds all over the northern country.

Despite the failure to secure a national cattle trail, cowmen continued to support the Stock Raisers' Association of Northwest Texas. In 1892 they changed the organization's name to The Cattle Raisers Association of Texas and invited ranchers all over Texas as well as Oklahoma and New Mexico to join. In the following year the association moved its headquarters to Fort Worth. In 1921 the name was changed again, this

time to The Texas and Southwestern Cattle Raisers Association, to reflect the area of its membership.

The association's inspectors have been courageous, diligent, and dedicated. Over the years they have sent hundreds of cow thieves to prison and retrieved thousands of cattle. Between 1883 and 1947 inspectors reclaimed more than one-hundred thirty-five thousand cattle worth nearly five million dollars. From 1968 to 1973 they recovered twenty-two thousand head worth nearly four and a half million dollars. Their work goes on, for as long as beef prices remain high, cattle will be stolen.

Richard Thompson. *Dinner Party.*

Richard Thompson. *Against the Fence.*

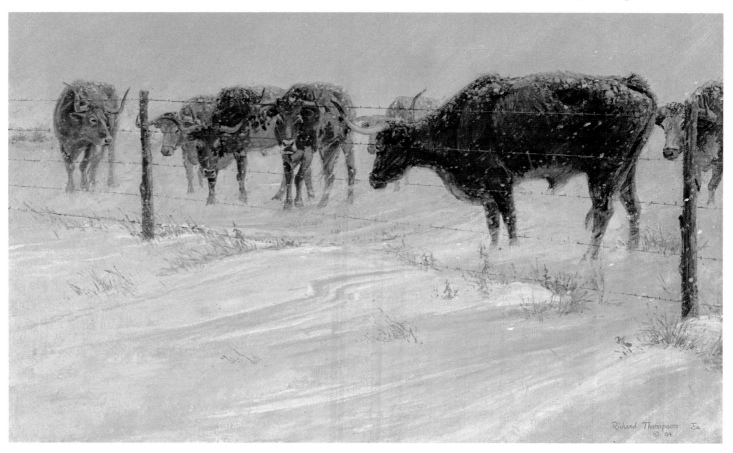

The Big Die-Up

BLIZZARDS AND PROLONGED FREEZING weather were among the costly hazards of open-range ranching on the Great Plains. Horses could paw through snow to grass but cattle were helpless when the snow was deep. Cattle would turn tail to a blizzard and drift with it until they reached sheltering breaks, were stopped by drift fences, or the storm ceased. When cattle couldn't reach grass for weeks on end or when the only available water was frozen solidly for days, many animals died. These conditions occurred in different areas from time to time but were rarely general throughout the West. But in the late 1880s, severe weather conditions marked the end of the cattle boom.

About the time that the National Convention of Stock Growers in St. Louis ended, the Chicago Board of Trade reported that western ranges were badly overstocked and that Texas fever was spreading. H. L. Goodrich, editor of *The Daily Drover's Journal* published in Chicago, offered cowmen some quaint but sound and timely advice: "If you have any steers to shed," he wrote, "prepare to shed them now."

The price paid for range cattle declined sharply at this critical time, and cattlemen were reluctant to sell. President Grover Cleveland ordered cattlemen, mostly Texans, to remove their cattle from the Cheyenne-Arapaho reservation, which crowded overstocked ranges even more. Then West Texas was hard hit by a series of fierce blizzards in the winter of 1885–1886, and a severe drouth that summer added to losses.

On the central and northern plains the extraordinarily severe winter of 1886–1887, which followed a summer drouth, caught ranchers totally unprepared. Losses were appalling. Whole herds were wiped out, and many ranchers and syndicates were ruined. Others barely survived. They called it the Big Die-Up. Cattle raising on the Great Plains was never the same again. Those ranchers who were able to rebuild were quite different in wealth and appearance from the cattle barons who had assembled in St. Louis two years earlier. The cattle boom was over.

Scottish cattleman John Clay, who managed British-owned ranches in the West, summed up the results of the cattle boom and the Big Die-Up: "The gains of the open-range business were swallowed up by losses. From the inception of the open-range business in the West and Northwest, from say 1870 to 1888, it is doubtful if a single cent was made if you average up the business as a whole."

After the Big Die-Up ranchers on the northern plains began fencing the land they owned or leased and had their cowboys spend summers cutting and stacking prairie

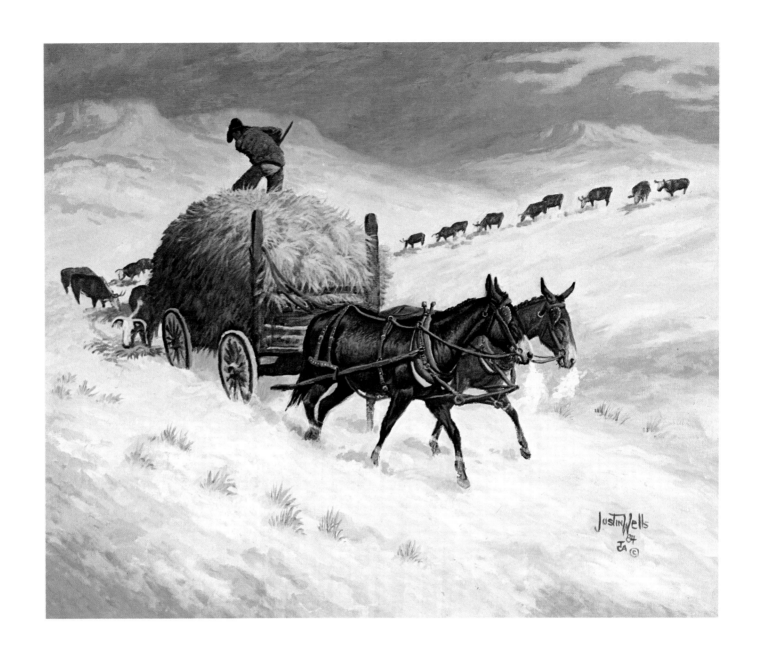

Justin Wells. *Feeding in Wintertime.*

Steve Devenyns. *Snowbound.*

hay for winter feeding. It was undesirable work for the cowboys, but it was necessary. The hay, put in stacks, was enclosed by fences, with gates that could be opened to let cattle in when weather turned bad.

Since ranges were now limited and grass no longer free, cowmen were obliged to upgrade their herds to produce more beef with fewer animals. In Texas some ranchers reduced their risks by using part of their land for sheep. "Cattle for prestige, sheep for profit" was a Texas saying.

Richard Thompson. *Harsh Winter.*

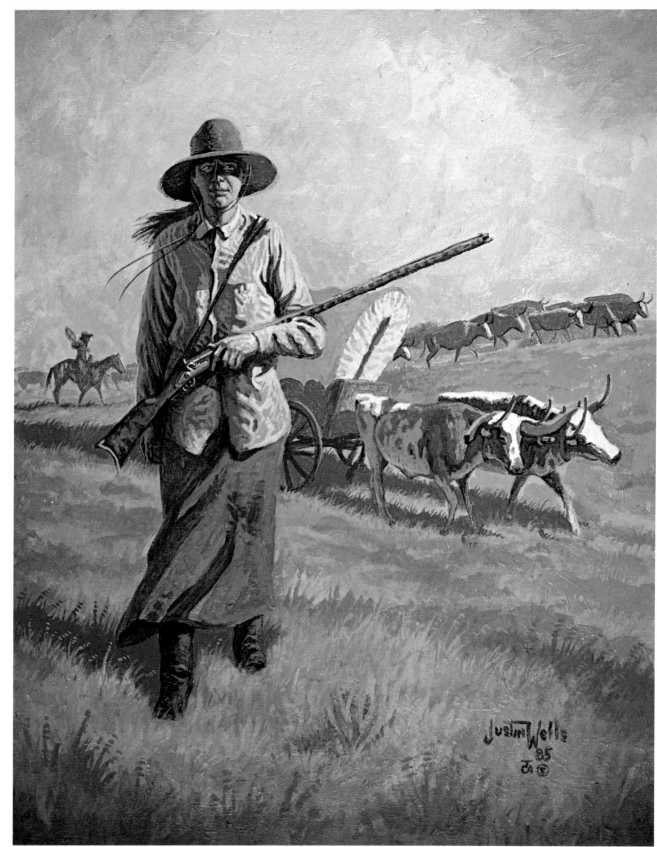

Justin Wells. *The Pioneer.*

Homesteaders and the End of the Open Range

U NLIKE OTHER STATES, Texas retained ownership of its public lands on entering the Union, because the federal government declined to assume the Republic's debts. In order to attract immigrants, especially farmers, the state followed a policy of making land easily available. At first it was virtually free; later it sold for from fifty cents to two dollars an acre, with easy credit and generous terms to farmers. The railroad companies, which before 1883 received thirty-eight million acres of state land, also sold land cheaply to homesteaders, for most of the railroads were undercapitalized and in need of cash.

Many obstacles and hazards faced families carving out small farms on the western frontier. Until 1875 there was constant danger of Indian attacks, and an average of two hundred people were killed or carried off each year. There was also danger from bands of lawless men until the Texas Rangers reduced the bandit population in the late 1870s and 1880s.

Variations in weather—drouths, floods, and blizzards—were another problem. Locust swarms at times ate every leaf on every stalk, wiping out entire cornfields. Pioneer families accepted these hazards and ultimately triumphed over them. The women spun and wove wool, churned butter, and did all the tasks necessary to put food on the family's table and clothes on their backs. They bore children, doctored wounds, and nursed the sick. When the chance came, families assembled from miles around for feasting and all-night dancing. And when enough families settled in any area, the men put up a one-room schoolhouse and hired a teacher.

Cowmen were generally tolerant of sodbusters providing they didn't fence off waterholes or springs that cattle were accustomed to using. Ranchers in West Texas considered the region suitable only for grazing and were less happy to see the homesteaders arrive. After the newcomers demonstrated that certain crops could be grown profitably, however, some ranchers allowed part of their land to be worked on shares or hired men to farm it. In this way they reduced the financial risks that were part of the unstable and undependable cattle business.

Garland Weeks. *A New Breed—A New Generation.*

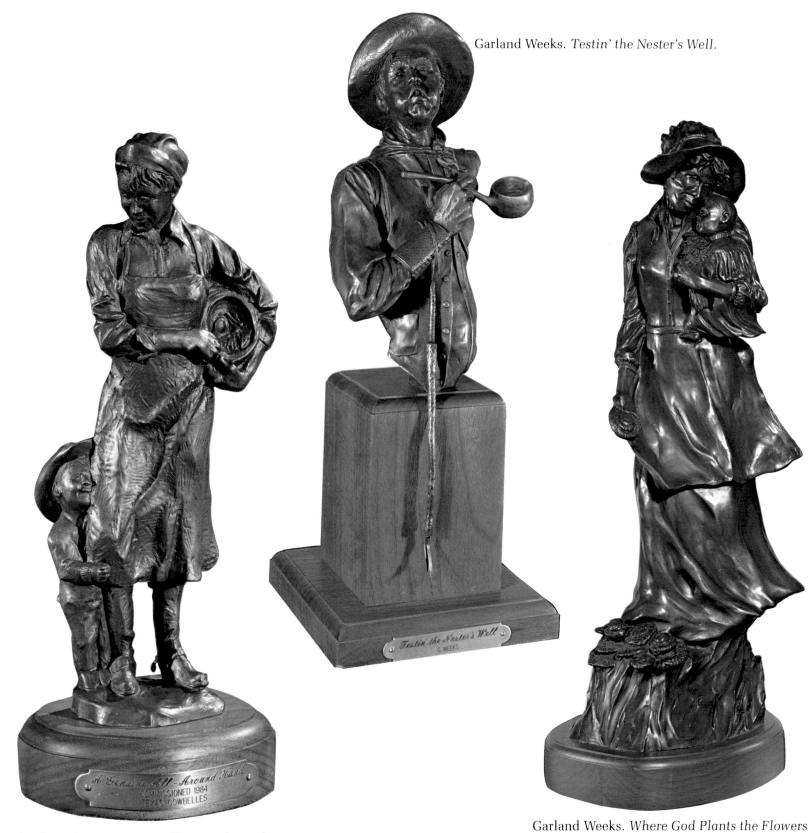

Garland Weeks. *Testin' the Nester's Well.*

Garland Weeks. *A Genuine All-Around Hand.*

Garland Weeks. *Where God Plants the Flowers and Cows Chop the Wood.*

Fencing the Range—
The Coming of Barbed Wire

AT THE DEKALB COUNTY, Illinois, Fair of 1873, one of the exhibits was a wooden rail with spikes in it to discourage cattle. Within a few months after seeing the rail, three county residents applied for patents for barbed wire. One of them twisted the barbs in his wife's coffee grinder and strung the wire from a windmill platform in order to put barbs on it. Two of the men, Isaac L. Ellwood and Charles Farwell Glidden, formed a partnership and perfected methods for producing large quantities of barbed wire.

Before the invention of barbed wire, fencing was an unsolved problem in Texas and on the Great Plains. Ellwood and Glidden knew that if Texas ranchers began using their wire to fence cattle ranges, the rest of the cowmen in the West would adopt the practice. Salesmen they sent to Texas convinced a few farmers that the wire was effective in keeping cattle out of fields, but the major cowmen were skeptical of its ability to hold Longhorns. In 1876 salesman John W. "Bet a Million" Gates staged a demonstration in San Antonio, where the major ranchers regarded the Menger Hotel as their headquarters.

Gates secured permission to build an eight-strand barbed wire corral in the old Military Plaza. To arouse curiosity he told no one what he planned. When the corral was completed and a crowd of curious people had gathered about it, Gates had some cowboys drive in and pen a small herd of Longhorns. To the astonishment of cowmen, after the steers charged the wire a few times they gave up. Gates took orders for carloads of barbed wire that day.

When the big ranches began fencing their ranges, they faced an enormous and costly task. The ultimate challenge in ranch fencing was the three-million-acre XIT. A contract to fence the northern part was let to former buffalo hunter Bill Metcalf. This section had permanent surface water at Agua Fría, Perico, and Buffalo Springs, so it could be stocked with cattle before wells were drilled and windmills erected.

W. S. Mabry contracted to survey the northern fence line. Metcalf's contract called for cedar posts every thirty feet, and Mabry was expected to put in stakes where the posts were to be placed. There was no wood available within many miles, so he had his men put mounds of earth in place of stakes. The winter of 1884–1885 was severe, hampering both the surveyors and the fence crew, but the northern line was completed in the spring.

Men were hired to cut posts in the cedar brakes along the Canadian River, and freighters hauled these to the survey line. Barbed wire for the four-strand fence was

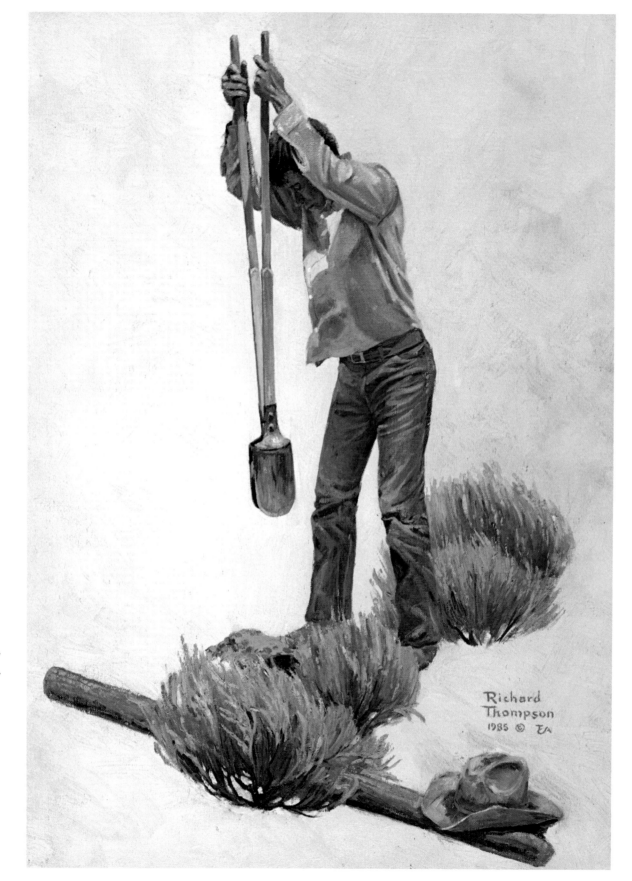

Richard Thompson.
Devil's Invention.

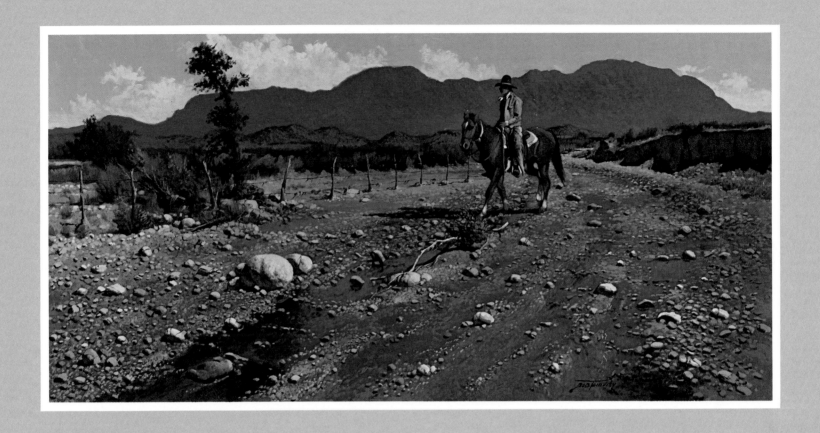

Bob Tommey. *Fence Line Rider.*

hauled in wagons from the railroad station at El Moro, near Trinidad, Colorado. The freighters unloaded four eighty-rod rolls of wire every quarter of a mile along the fence line. The northern fence was one hundred sixty-two miles long, and it enclosed bands of mustangs and a few buffalo.

Late in 1885 a contract for fencing the southern part of the ranch was let to Ben Griffith and a Scot, J. M. Shannon. Griffith soon gave up, but Shannon overcame many difficulties and fulfilled his contract. He had to hire freighters to haul wire and other necessities from Colorado City, Texas, but they refused to scatter it along the line and unloaded it thirty miles from where it was needed. Shannon worked hard for eighteen months, stringing eighty-five miles of fence at the cost of one-hundred ten dollars per mile, losing thirty dollars on every mile.

By the fall of 1886 the XIT had contracted for around seven hundred eighty miles of fence. The west line, two hundred sixty miles long, began in the northwest corner of the state and extended one hundred fifty miles without a turn. The east line was two-hundred seventy-five miles long, and line riders checked on five hundred seventy-five miles of outside fences. In the 1890s the XIT was cross-fenced into ninety-four pastures, making a total of about fifteen hundred miles of fences. An estimated three hundred carloads of materials had been used, including six thousand miles of barbed wire, a hundred thousand fence posts, five carloads of wire staves, one carload of staples, and another of gate hinges.

Fence crews moved along fairly rapidly. Some men dug post holes, some tamped the posts in place, others unrolled the wire and stretched it, and yet others stapled the wire to the posts. They strung strand after strand, like railroad crews putting down cross-ties and laying track. Thousands of miles of fence were built on the big Texas ranches, ending forever the era of open range and free grass and with it the day of the Longhorn, mustang, and old-time Texas cowboy.

Cattle in the Tally Book
or Cattle on the Hoof

BEFORE THE CATTLE BOOM, when a Texan purchased a brand from a rancher he customarily accepted the figures shown in the tally book without rounding up and counting the cattle. With the brand he acquired not only the cattle but the rancher's range rights. The state owned most of the land, but by custom the first cowman to run his cattle on any range claimed it, and others respected his right to use it.

A rancher's honor and reputation were and often still are his primary concern. "I'd rather argue with you a week before a trade than a minute afterward," one old-time cowman said. Many Texas ranchers today still feel the same way.

At the height of the cattle boom of the 1880s eastern and foreign investors did not hesitate to buy whole herds by tally book count. But the high prices that cattle brought had stimulated rustling as well as overstocking of the ranges. Rustlers stole hundreds of cattle in the 1870s and 1880s, and overgrazing, followed by a series of drouths and extremely severe winters, killed thousands more. Under these conditions buying herds by tally book count proved disastrous for many incautious investors; they paid for hundreds of cattle they didn't receive.

One winter when prolonged cold weather and heavy snow killed many cattle, ranchers were glumly discussing their prospects in a saloon. "Cheer up, boys," the bartender said, "whatever happens the tally books won't freeze."

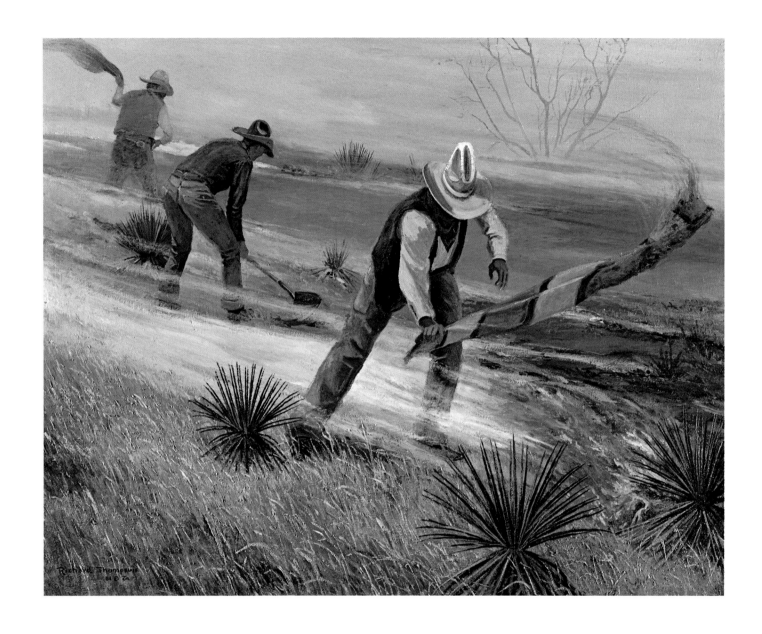

Richard Thompson. *Firefighters.*

Terror on the Open Range—
Prairie Fires

PRAIRIE FIRES were one of the most dreaded calamities of the open range, for they were fast-moving and devastating. When the grass was dry and a strong wind was blowing, they swept along with incredible speed, destroying everything in their path. Wild animals, cattle, and horses caught in the path of a prairie fire were lost unless they could reach a river or lake. Men could save themselves by lighting backfires and taking refuge on the burnt areas once the flames had moved on.

When the rangeland was burning, cowboys from the nearest ranches assembled to fight the fire. Often they shot a young steer, and two cowboys attached ropes to it and dragged the carcass rapidly along the edge of the fire, snuffing it out. Other men followed with brooms, saddle blankets, chaps, or wet feed sacks to beat out the remaining small fires.

Many ranchers on the plains hired men to plow firebreaks around their land each year. When the flames were fanned by strong winds, however, flying sparks ignited the grass beyond the firebreaks. Unless there were men ready to stamp out the small fires that were started in this way, the flames soon roared on, leaving the range a blackened, smoky vista of hell.

Harold Holden. *First Day in School.*

Cow Ponies

A GOOD COW HORSE was said to have cow sense when it learned to handle a herd with little guidance from its rider. If an animal quit the herd, the cow pony went after it and turned it back. Ponies were also trained for roping; before the building of branding chutes, the only way range cattle could be handled for branding or doctoring was by roping them and tying them down. The ponies were trained to bring their riders close enough to rope an animal and, when the catch was made, to slide to a stop and keep the rope tight.

In the old days a cowboy handled a steer by himself. He roped a steer by its horns, then flipped the slack over its hindquarters above the hocks while the horse was reined to the left and spurred past the steer. The rope tied to the saddle horn caused the steer to trip as the cowboy rode past him. The pony dragged the steer while the cowboy stepped off and tied three of the steer's feet together with a hogging string, a short rope he had tucked under his belt.

At first, roping horses were trained to face away from the roped animal and to pull forward. Later they were taught to face it and to back up to keep the lariat taut. A well-trained roping horse was a necessary tool and a source of cowboy pride.

Some cow ponies were, of course, better than others, and a special few had the sense and agility to enable them to separate an animal from a herd and keep it from turning back. These were the elite of the cow ponies—cutting horses.

Big ranches in the old days might have several ponies good enough to be used for separating cattle of different brands at the roundup gathering grounds. Because these skills were rare, cutting horses were allowed to specialize and weren't used for other cow work. As one old-time cowboy said, "Cutting horses are the smartest; sheepdogs are next; and college graduates are third."

Cowboys were inclined to brag a bit about their ranches' cutting horses—some claimed theirs could even read brands. Others reported that they had seen their cutting horses practicing on cattle after they had been turned loose on the range. It was only natural that competition between ranches developed. From these informal tests of skill emerged the modern cutting horse contests, where horses are judged by strict rules on their ability to cut out a yearling and keep it from returning to the herd.

The ability of a cutting horse to keep up with and anticipate the quickest movements a calf makes is astonishing and a pleasure to watch. The rapid turns, changes of

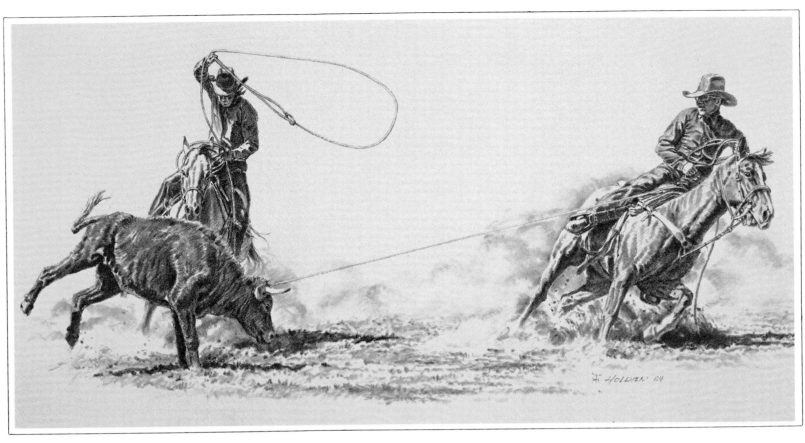

Harold Holden. *Teamers.*

direction, and stops a cutting horse must make require a rider who can keep his seat while leaving the reins loose and allowing the horse to work without help or guidance.

For many years cutting horses moved cat-like from side to side while facing the yearling. This somewhat unnatural action, while impressive to watch, was changed in the 1960s. Since then cutting horses turn with the calves and run alongside them to turn them back. Trainers agree that this change of style is an improvement.

Cutting horse contests have developed rapidly in the past thirty years, and today the breeding and training of cutting horses is a thriving business. Top horses and their progeny command prices that reach five figures.

The National Cutting Horse Association was organized in 1946 at the Southwestern Exposition and Fat Stock Show in Fort Worth. The association today maintains offices in that city.

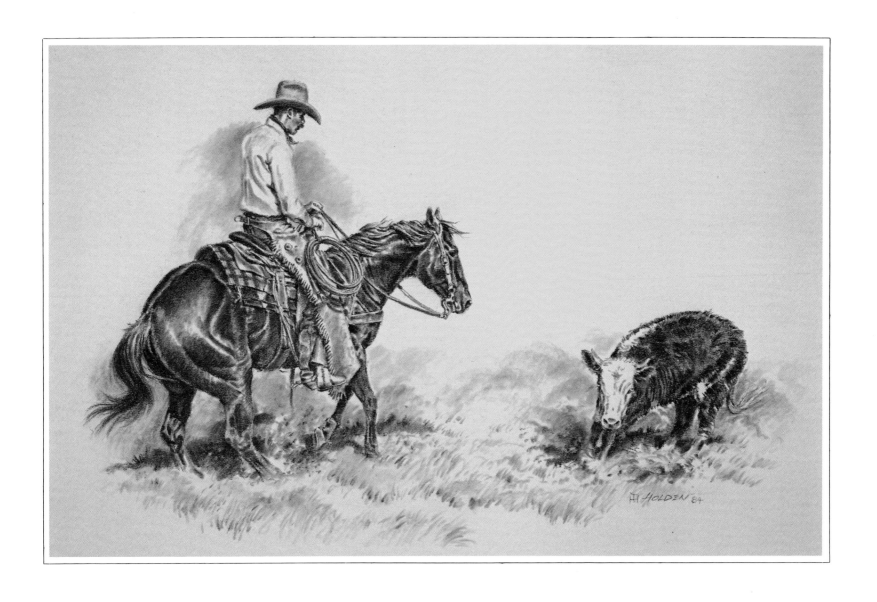

Harold Holden. *Turnin' 'Em Back.*

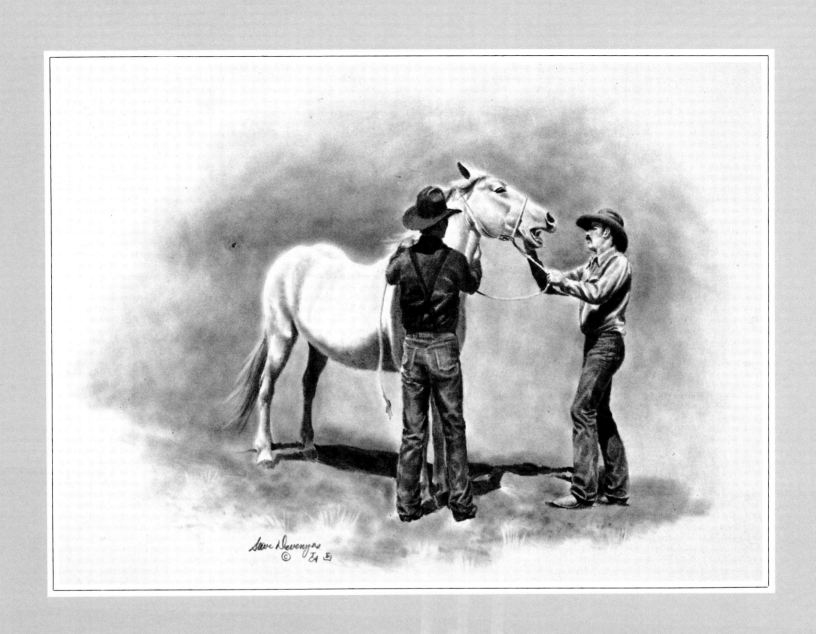

Steve Devenyns. *Bringing in New Blood.*

Quarter Horses

HANDLING SEMI-WILD CATTLE on the open range required cow ponies that had cow sense and were agile, versatile, and tough. Mustangs, though small, made excellent cow ponies, for they were alert, quick to learn, and long-winded. When crossed with blooded stallions—Quarter Horse, Thoroughbred, or Morgan—they produced offspring that were larger, swifter, and more powerful.

The Quarter Horse, today the most popular saddle horse throughout the world and considered by many to be the ideal cow pony, was brought to Texas in the early nineteenth century.

The Quarter Horse originated in seventeenth-century Virginia and other colonies, where most settlements had two parallel paths a quarter of a mile in length for sprint races. The animals were extremely fast for short distances and were known as Celebrated American Quarter Horses. In the eighteenth century, if not earlier, they were of the same breeding as the forerunners of the English Thoroughbred, and some were fast at any distance up to four miles.

Quarter Horses accompanied pioneer farmers and cattlemen across the mountains to Kentucky and Tennessee. Although some were undoubtedly brought to Texas by Anglo colonists in the 1830s and 1840s, Quarter Horses were still not numerous enough during the cattle-trailing era to supercede mustangs. But most remudas contained at least one Quarter Horse for racing. Texas cowboys who wanted to race needed only an open space and fairly level ground. Challenges were exchanged between the dozens of herds on the trail during the height of the trailing season, and races were arranged along the way. There was usually more racing and betting at the end of the trail.

In the 1930s Robert Moorman Denhardt, a young historian at Texas A & M College, visited Quarter Horse breeders all over the West. He discovered that the best animals traced to a relatively few well-known sires. Denhardt began writing books and articles about Quarter Horses and realized that the breed should have a registry in order to retain its purity. In 1939 he and others invited Quarter Horse breeders to a meeting in Fort Worth to consider forming an association and registry. Few were able to attend the meeting, but those who did helped arouse interest in the project.

In 1940 a large number of enthusiastic Quarter Horse breeders assembled in Fort Worth and organized the American Quarter Horse Association, established a registry,

and set rules for eligibility. The AQHA, with headquarters in Amarillo, has grown rapidly over the years because of the increasing popularity of the Quarter Horse for activities other than racing. Today it is the most popular saddle animal in America and is widely used for ranch work, rodeo events, and as a cutting horse. Quarter Horse races are held in states where racing is legal, with some of the largest purses in racing.

Mark Storm. *Better than Ever.*

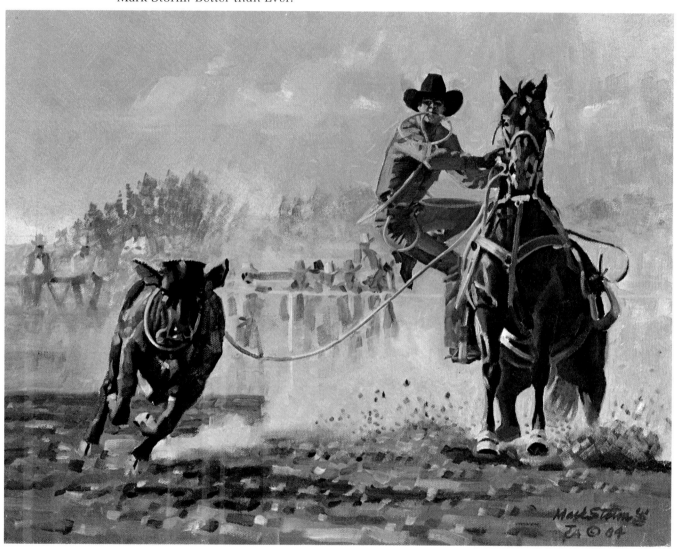

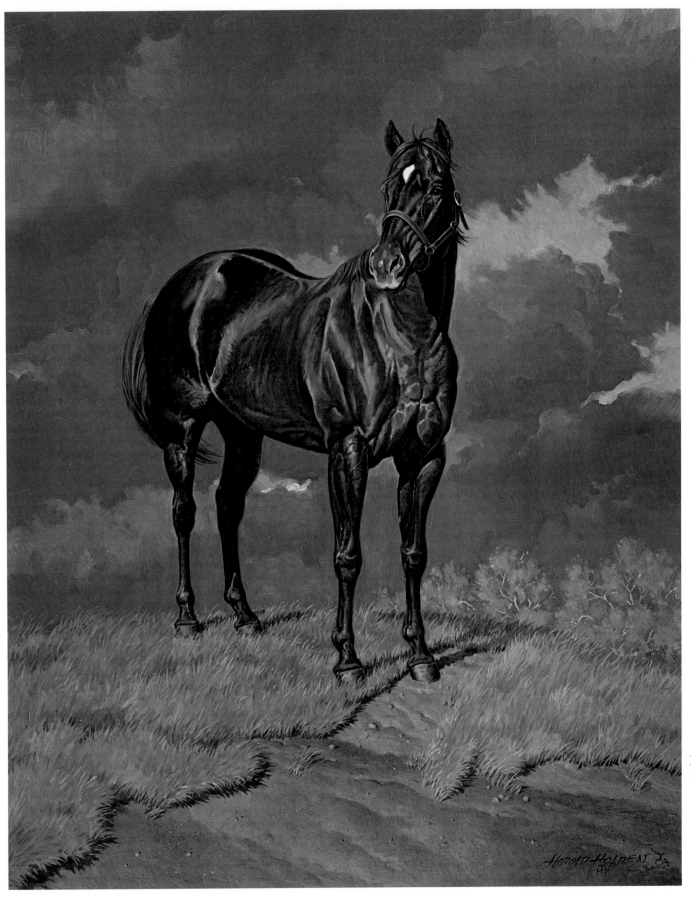

Harold Holden.
With Prejudice.

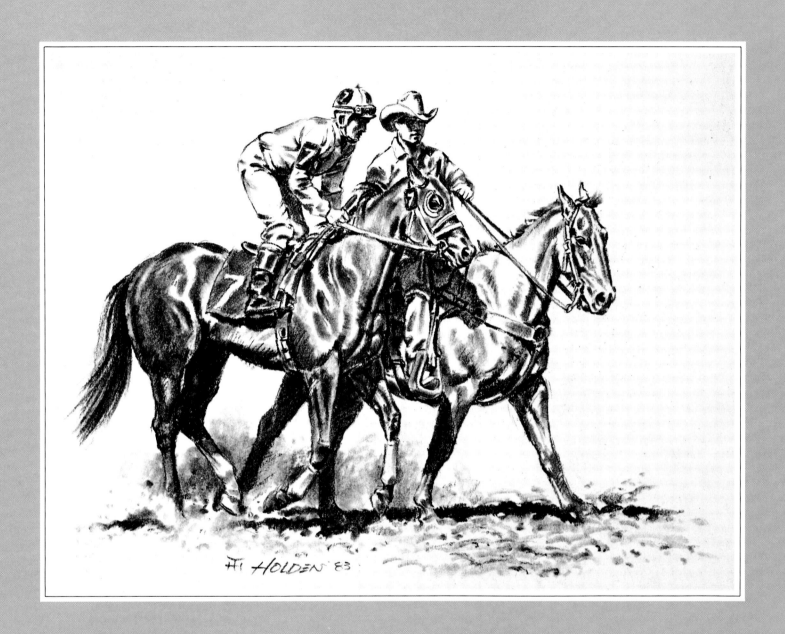

Harold Holden. *To the Gates.*

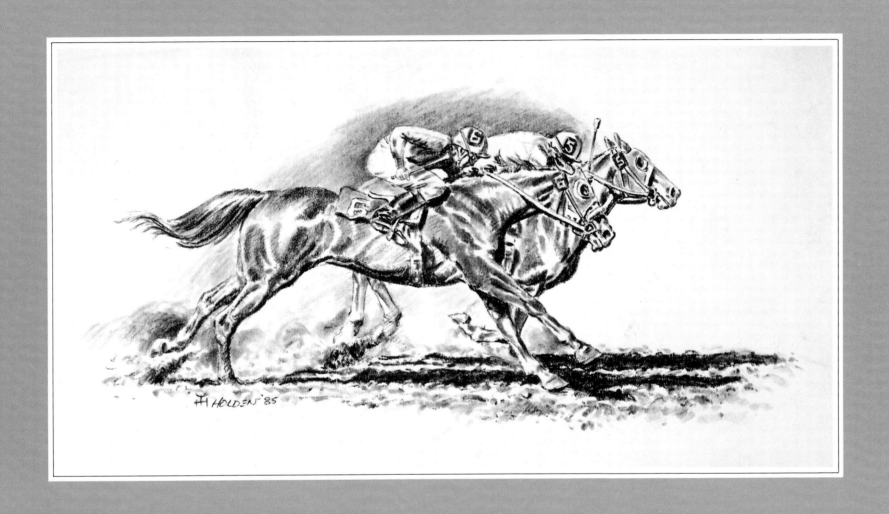

Harold Holden. *By a Nose.*

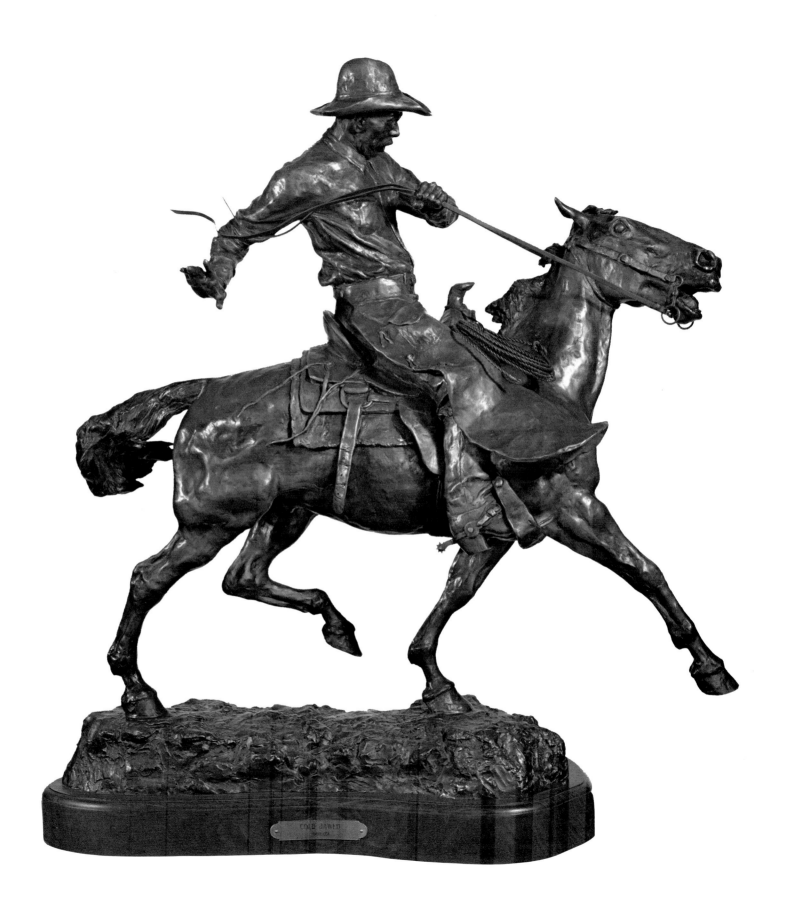

COLD JAWED
Bronze

Rough String Rider

THE LARGE RANCHES of the late nineteenth century always had some outlaw horses that the average cowboy couldn't handle. Many of these animals were vicious and would bite or kick anyone who approached them. Others were sly and deceptively behaved themselves until the rider was preoccupied with roping or grew careless; then the horse would blow up and ground him. Many rough string horses were tough and tireless and couldn't be worn down by hard riding. These made excellent circle horses for the big open-range roundups. Some rough string horses were lifelong outlaws, but others eventually reformed and became good cow horses.

There were exceptionally good riders who could handle outlaws, and ranchers paid them extra to ride rough string horses. Often it took two or three men to saddle these animals. Some, like the Strawberry Roan of the old song, had to be blindfolded before they could be saddled. Without rough string riders, these horses could not be made to earn their keep.

Rough string riders were a special breed, part dare devil, part bronc buster. Theirs was a dangerous occupation; some were killed by outlaw horses, and many were injured. They earned their extra pay.

Jimmy Cox. *Cold-Jawed.*

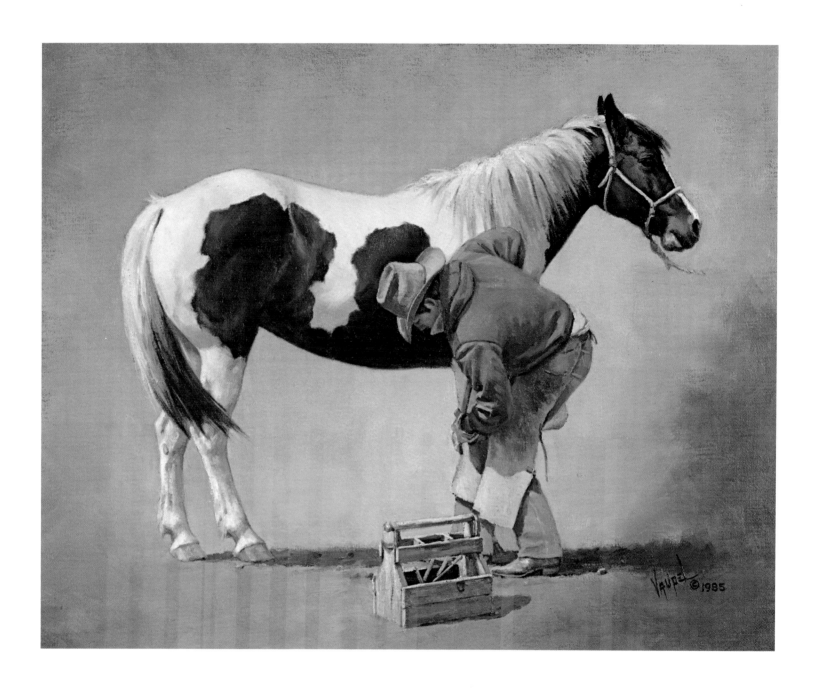

Horse Shoeing

IN THE EARLY DAYS each cowboy had to shoe his own string of horses, although mustang cow ponies had tough hoofs and could be ridden unshod. Some cow horses never became reconciled to the shoeing process and had to be handled with caution. A few outlaws kicked and pawed and bit anyone who approached them; the only way to get shoes on them was to throw and hogtie them.

Eventually professional farriers were available to do the shoeing. People brought their horses to them, or they traveled in wagons to places where there were large numbers of horses to be shod. Some of the farriers were stove-up cowboys who were no longer able to do hard riding. Today there are a number of farriers in every area where horses are numerous. They carry everything needed in pickups, and some cover a wide area.

Barbara Vaupel. *Rasping a Hoof.*

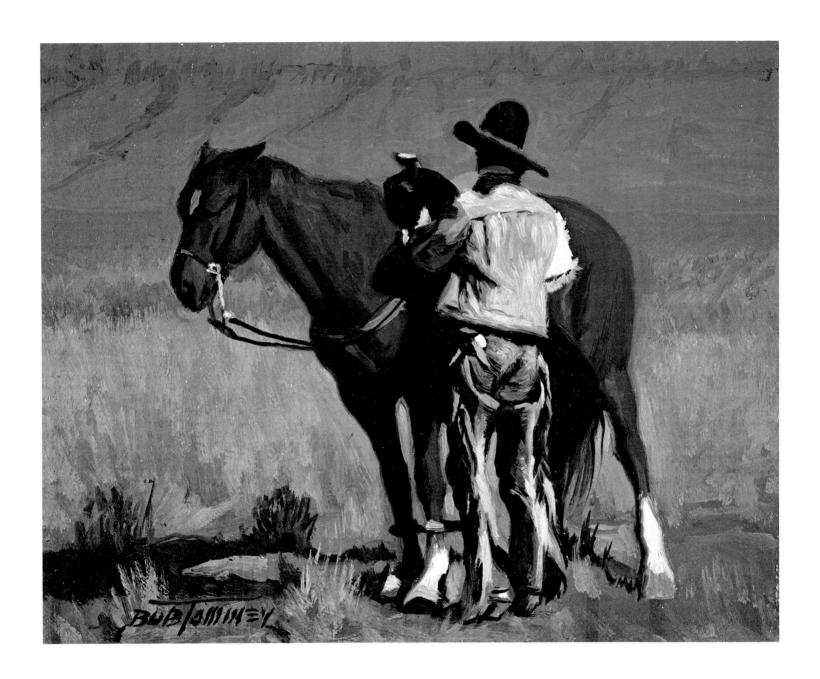

Bob Tommey.

From Dugouts to Bungalows

WHEN COWMEN FIRST MOVED into West Texas, they found no timber for building cabins. They camped in the open without shelters while they prepared dugouts. A dugout was a small cave-like room hollowed out of the side of a hill near a stream or spring. It was reasonably warm in winter and cool in summer, although the door was usually little more than a cowhide. Camps for line riders who daily rode the boundary line to keep cattle from straying were generally dugouts.

Later, ranch houses for the cowman and his family were built of lumber hauled in wagons from the nearest railroad. The early ones were little more than cabins and not the mansions of later days. At the same time, bunkhouses or bachelor quarters were built for the cowboys. These were simple structures with little in the way of decoration except pictures torn from magazines and nailed to the walls. Cowboys slept on primitive mattresses that were simply sacks stuffed with prairie grass or corn shucks.

Since cowboys were a nomadic species, Texas cowmen didn't worry much about making them comfortable. On ranch or roundup, the food provided was always simple fare such as bacon, beans, sourdough biscuits, and molasses. One reason so many Texas cowboys stayed on northern ranches after trailing cattle to Wyoming or Montana was that the owners there were often easterners or Englishmen who enjoyed accompanying the roundup crews. On such ranches cowboys slept in tents and ate fancy foods. Many Texas cowboys saw white sugar for the first time on northern ranches and mistook it for salt.

Like their living arrangements, cowboys' religion was far from fancy. Cowboys had few opportunities to attend church or revival meetings. They weren't totally oblivious to matters of a religious nature, however. During severe thunderstorms on roundups or the trail they were likely to make extravagant promises concerning what they would do if they survived the storm. The next morning most of them sheepishly joked about their vows.

In truth, although they made no show of their religion, many cowboys carried worn and dusty bibles in bedrolls and saddlebags. The basics of the Gospel, the wisdom of the scriptures, and the appreciation for God's gifts of nature form the foundation for a religion not shaken by die-ups, drouths, rustlers, and a falling market.

At one ranch a wandering preacher found only the cowman at home. He had come to preach, and the smallness of the congregation didn't discourage him. His sermon was

Garland Weeks. *Mail Order Lesson #1.*

long and windy. When he finally got to the "Amen" part, he asked the rancher what he thought of it. "When I have a wagonload of cottonseed cakes for cattle and find only one ole bull, I don't unload the whole damn wagon on him," the rancher replied. Cowboys said of such lengthy sermons that they had "too much mane and tail."

Itinerant preachers or circuit riders occasionally visited the ranches of a region to deliver sermons. They also helped build "meeting houses," established congregations, married the young folks, conducted funerals, helped with the work, started and maintained camp meetings, and generally did what needed to be done. The long rides between settlements and nights spent under the stars were times for deep study and meditation.

Today, the circuit rider is gone, and the cowboy's life is different, and, in some ways, more conventional. Since World War II ranchers have had difficulty in keeping dependable bachelor cowboys and have had to rely on married men. This has meant that ranchers' attitudes have had to undergo a change, for they can no longer ignore the comfort of their hands. They are obliged to furnish satisfactory houses and make other concessions to keep families contented, for if the wives are unhappy the husbands soon depart.

Modern cowboys with families are generally stable and much less inclined to wander than the old-time cowboys, who were fiddle-footed and not likely to stay on one ranch or in one region for long. Most of them gave up cowboy life by the time they reached their thirties—old cowboys were rare. Now family cowhands are likely to work their entire lives on one of the big ranches.

Garland Weeks. *The Old Rugged Cross*.

Garland Weeks. *San Antone.* Garland Weeks. *Saturday Night.*

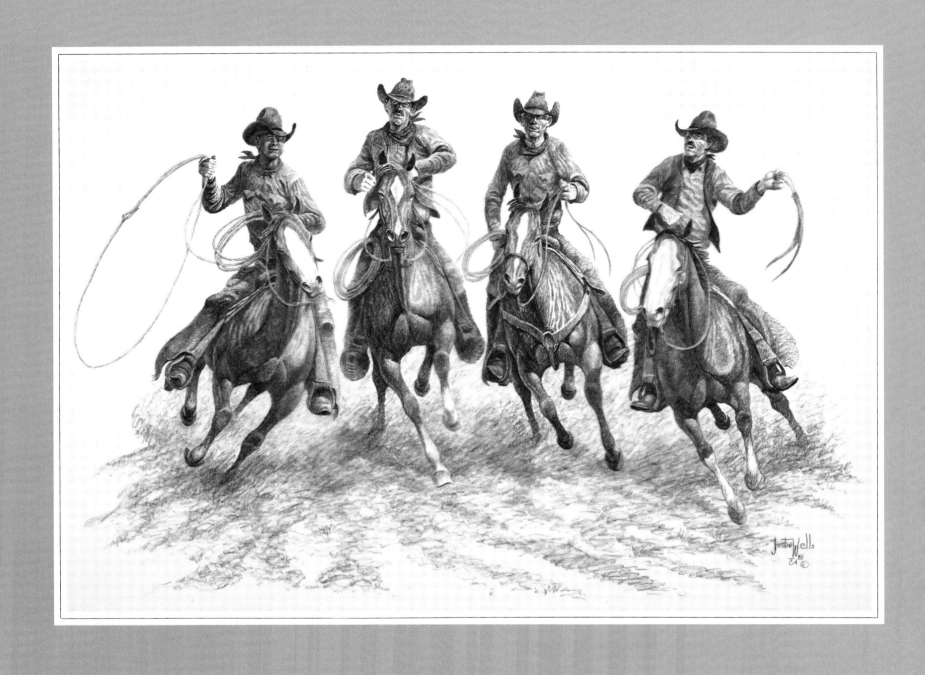

Justin Wells. *The Texas Cowboys.*

Stetsons, Justins, and Levis

IN THE LATE 1860s Texas cowboys wore whatever was available, including the remnants of Confederate uniforms and army boots. Most wore longjohns except in the hottest weather. Shirts were of flannel or cotton, and before Levis were available in the 1870s, pearl gray California pants or woolen ones reinforced with buckskin on the seat and inner thighs were popular. Most cowboys wore vests and kept the "makings," a pack of Bull Durham tobacco, cigarette papers, and matches, in vest pockets.

All cowboys wore hats. Before Stetsons were on the market, hats were of a variety of styles and shapes and might be straw or felt. After 1871 Stetson hats became the favorite. Stetsons were dented and creased in particular ways in each cattle region, so that one could tell by his hat where a cowboy hailed from.

Tight-fitting high-heeled boots became standard after the Civil War. H. J. Justin, one of the many boot makers found in western towns, contributed much to the development of the cowboy boot. At Spanish Fort in 1879 he began repairing boots until a cowboy offered to furnish the leather if Justin would make him a pair. Soon he was taking orders from cowboys heading up the trail, so they could pick them up on their return. After he moved to Nocona in 1889, his wife developed a self-measuring kit and he began a mail order business. Later he moved to Fort Worth and expanded operations. His boots became so popular among cowboys that *Justins* came to mean boots, as *Stetsons* and *Levis* had come to mean hats and pants.

Chaps, which were necessary in brush country or foul weather, came to be of two styles in Texas, shotgun and batwing. Shotgun chaps were like pants, with a fringe down the outside seams. Batwings were fastened around the legs by snaps. In the northern plains cowboys wore Angora chaps or *woolies* in the winter.

A cowboy's most prized possessions were his hat, boots, and saddle. "He sold his saddle" meant that he was finished. The western stock saddle evolved from the vaquero saddle, and a variety of styles developed in different regions. The Santa Fe and California saddles were popular with cowboys because they were light, and the Pony Express saddle was later patterned after them.

All stock saddles were basically similar, but there were many variations in details. They could be centerfire (single cinch) or rimfire (double-rigged). Other differences were in the height, shape, and angle of the horn. The early saddles were all *slick*, and cowboys often tied a rolled up blanket behind the horn to make it easier to stay on

Apple Horn
Mother Hubbard Saddle,
1860s

Jim Ward.

bucking horses. In the 1890s some saddle makers introduced the swelled fork, like the saddles used on bucking horses in modern rodeos. At first cowboys scoffed at them, but because the bulges helped them stay on rough horses they soon became standard.

There were a number of well-known saddle makers in the 1880s and 1890s such as Padgitt Brothers of Dallas, Edelbrock of Fort Worth, and S. D. Myers of El Paso. A few companies are still in business, such as those founded by Herman H. Heiser and Fred Mueller of Denver, and by Newton Porter, who started in Colorado City, Texas but moved to Phoenix, Arizona.

Bronc Saddle, 1924

Low Association Tree, 1978

Texas Slick Fork, 1900

Jim Ward.

Medium Swell Fork, 1910

Texas Trail Saddle, 1880

Jim Ward.

Hope-Style Saddle, 1846

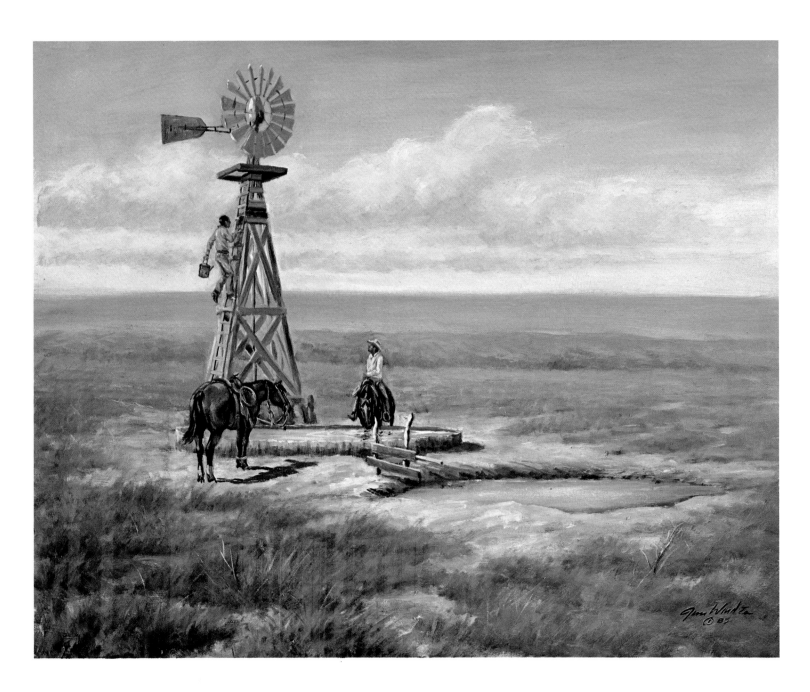

Jim Ward. *Greasin' the Wheel.*

Climbing for Water—
Windmill Men

WHEN THE INDIAN MENACE in West Texas was removed in 1875, cattlemen moved steadily westward until they came to the Caprock marking the edge of the Llano Estacado or Staked Plains. This was the region that Coronado's soldiers called a "sea of grass" in the 1540s. It was ideal cattle country except for one serious flaw— there was little permanent surface water.

In the late 1870s and 1880s professional well drillers using horse-powered equipment came to West Texas, followed by windmill salesmen. The problems of providing water for range cattle were soon solved, for the country was open and there were steady winds. Wells and windmills made it possible to graze cattle on the Llano Estacado and elsewhere in West Texas where there were few streams or springs.

Barbed wire had forced cowboys to become post hole diggers and wire stringers. Windmills caused some of the mechanically minded hands to be converted into windmill men. For cowboys neither change was welcome; they disliked any work that couldn't be done on horseback. But the windmills, with their wooden towers and blades to catch the wind and their primitive machinery, required constant attention and frequent repairs. Since cattle on the range for ten or more miles around each windmill depended on the water it pumped into an earthen stock tank, a broken windmill had to be repaired immediately or the cattle would soon have to be moved. Big ranches in West Texas might have dozens of widely scattered windmills, so several men constantly made the rounds to be sure that each was in working order.

Wells had to be drilled on the southern section of the vast XIT ranch which had little surface water. Marshall and Jones, who contracted to do some of the drilling, had a difficult time penetrating rock layers with horse-powered drills.

At first horse-powered pumps were used to raise water into cypress tanks that were twenty feet in diameter and cost from seven hundred to one thousand dollars apiece. In 1892 an experiment showed that earth tanks would hold water if they were thoroughly trampled by cattle or horses. Several two-hundred-pound sacks of salt were put in the bottom of each new earth tank. By the time the cattle had eaten all the salt the tank was thoroughly trampled and would hold water. By 1900 the XIT had three hundred thirty-five windmills in operation.

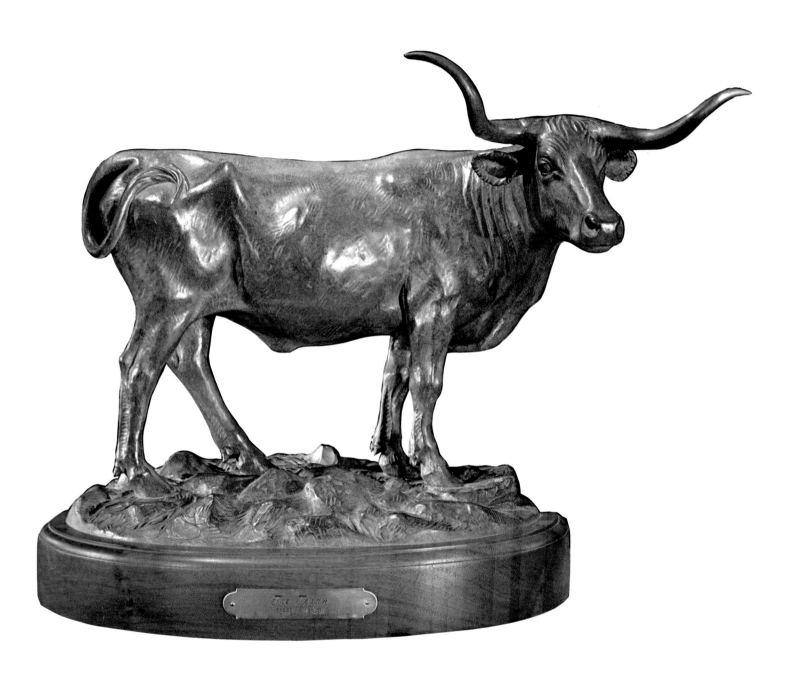

Terrell O'Brien. *The Texan.*

Comeback of the Texas Longhorn

IN THE DAY of the open range few ranchers were concerned about improving the quality of their cattle. In Texas all cattle of any class—yearlings, two-year-olds, and so forth—sold for the same price regardless of size or weight, so there was little incentive to invest in expensive bulls. Without fenced pastures, furthermore, there was no way of controlling breeding and being sure that your bulls remained with your cows. Bulls for breeding were selected at random—on the spring roundup every tenth bull calf was not castrated, regardless of his quality. "He won't make much of a steer," a rancher might say of a calf, "so leave him a bull."

As long as grass was free it mattered little that it took four years for Longhorns to mature. Longhorns had proved themselves ideal trail cattle, for if conditions were favorable they gained weight on the way to market. But the trailing era was nearly over and the open range was receding. Ranchers needed cattle that could be marketed in two years rather than four.

The first step in upgrading cattle was to cross Longhorns with Durham cattle. When ranchers learned of the Hereford's superiority as a range animal, the whiteface craze struck, and hundreds of Hereford bulls were brought from the East or Midwest.The Longhorn was virtually bred out of existence except in the brush country between the Nueces and the Rio Grande. All but a few ranchers forgot the Longhorn's assets such as resistance to disease, fertility, and ability to thrive on marginal pastures.

A few old-timers such as Emil H. Marks, Russell S. Stanger, and Ira G. (Cap) Yates continued to maintain small herds of pure Longhorns to cross with other breeds, but the Longhorn, which had helped Texas recover from economic ruin after the Civil War, seemed doomed to disappear. Emil Marks was confident that Longhorns would again be an asset in commercial beef herds, but others were skeptical.

In the 1920s several former cowmen who worked for the U.S. Forest Service at the Wichita Mountains Wildlife Refuge in Oklahoma were determined to save the Longhorn from extinction, just as the buffalo had been saved. In 1927, with a three-thousand-dollar grant from Congress and the help of former range inspector Graves Peeler and other Texas cowmen, Will C. Barnes and John H. Hatton gathered a carload of Longhorns in South Texas and shipped them to the Wildlife Refuge. A few years later Peeler helped locate twenty cows and two bulls for the state parks at Mathis and Brownwood because J. Frank Dobie and other Texans felt that the state should also maintain

Steve Devenyns.

herds of the historic Longhorns. Peeler also bought the nucleus of a breeding herd for himself and raised Longhorns for nearly half a century thereafter.

When the Wildlife Refuge began selling its surplus cattle each year, cowmen from Texas and other western states bought them as historical curiosities. Before long they rediscovered the Longhorn's good qualities. Longhorn calves are small at birth, and first-calf heifers of various breeds drop their calves easily when bred to Longhorn bulls. The half-Longhorn animals do well in feedlot growth.

Texas cowmen who attended the Wildlife Refuge sales regularly each year often discussed forming a Longhorn association and registry to preserve the breed. In 1964 they established the Texas Longhorn Breeders Association of America (TLBAA) with Charles Schreiner III as president. The association has grown steadily, and the use of Longhorn bulls on first-calf heifers has spread widely among ranchers. The value of Longhorns has risen dramatically—the average price per head paid at the Wildlife Refuge sales has risen from around two hundred dollars in 1963 to upwards of two thousand dollars in 1981. After almost disappearing, Longhorns have made a remarkable comeback and justified Emil Marks' faith in their ability to contribute to commercial beef cattle.

Jim Ward. *Cowboy Nostalgia.*

Jim Ward. *Spooked.*

Pickups and Eighteen-Wheelers— Trucks in the Pasture and on the Road

BARBED WIRE, quarantines, and the railroad brought major changes to the range-cattle industry. More recently the use of cattle trucks has generated yet another change in the cattle business that was, perhaps, as sweeping as the earlier dramatic changes. Trucks have many advantages over railroads, for they can go whenever and wherever there are cattle to be moved and deliver them anywhere in the country. Flexibility of route and schedule are major assets. The trucks of the 1920s and 1930s weren't big enough or sufficiently reliable to capture the entire cattle-hauling business. Only after World War II were truckers able to displace the railroads completely as cattle haulers. Today the double-decked eighteen-wheeler has replaced both the trail drive and the railroad car.

While big outfits use the eighteen-wheelers, the small cowman today moves his own stock to any Texas market he chooses with the goose-neck and other smaller, straight-tongue trailers, or even the ranch pickup.

The goose-neck trailer is a Texas invention, modeled on the old horse-drawn road grader. The first commercially successful version of this trailer was sold in the 1950s; the basic design has not changed much since then.

The horse trailer is another Texas development. Various improvements over the years have made trailer travel safer for horses than it was in the day of the open-air rigs of the 1920s and 1930s. Today's trailers boast steel frames and are designed to ride without jerks, whips, or sways at any speed.

The pickup truck, which has become standard equipment on all ranches, has also had a marked effect on ranch work, especially as a time and labor saver. A couple of cowboys can haul their horses in a trailer to any place they need to work cattle, saving hours of riding time going and returning. They can get their work done and be back at the house in time to see their kids while it's still daylight. "Used to be," one hand explained, "a man had to get up thirty minutes before bedtime, rope one of them snaky horses, and ride for an hour just so he could go to work. Now he can have breakfast with his wife, go out, prowl a couple of pastures, and be in town for coffee by 8:30."

The energy crisis and high cost of gasoline put some cowmen back in the saddle, making them aware of what they had been missing. "There's always something healthful about being out where there're no machines," a cowman said, "on a good horse working good cattle and knowing that even though there are trucks waiting at the pens to load your cows and haul them to town, there's still work to be done the way it was a hundred years ago."

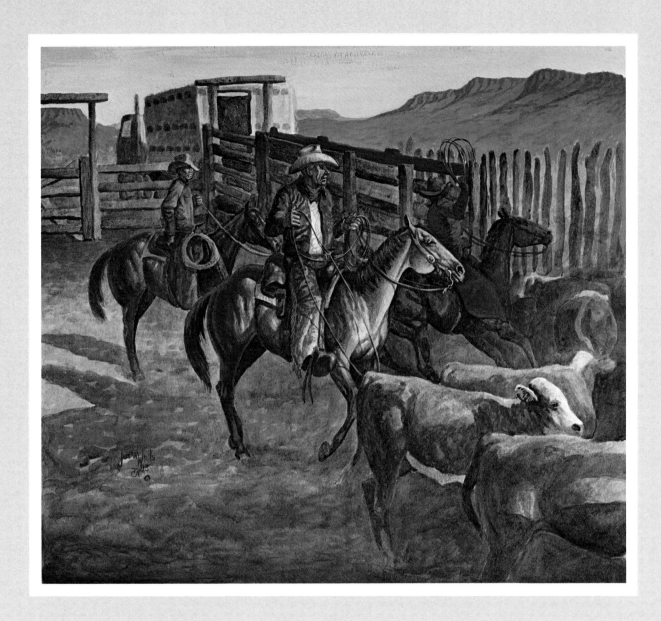

Justin Wells. *Loading Calves.*

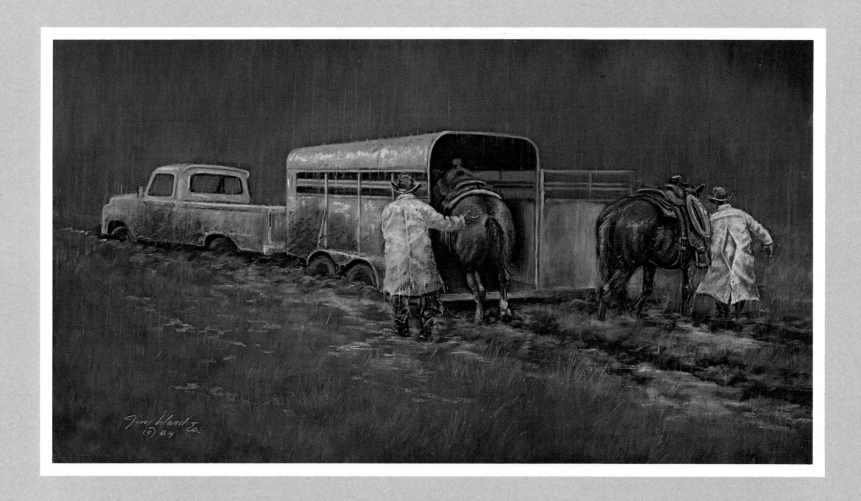

Jim Ward. *When Weather Dictates Choices.*

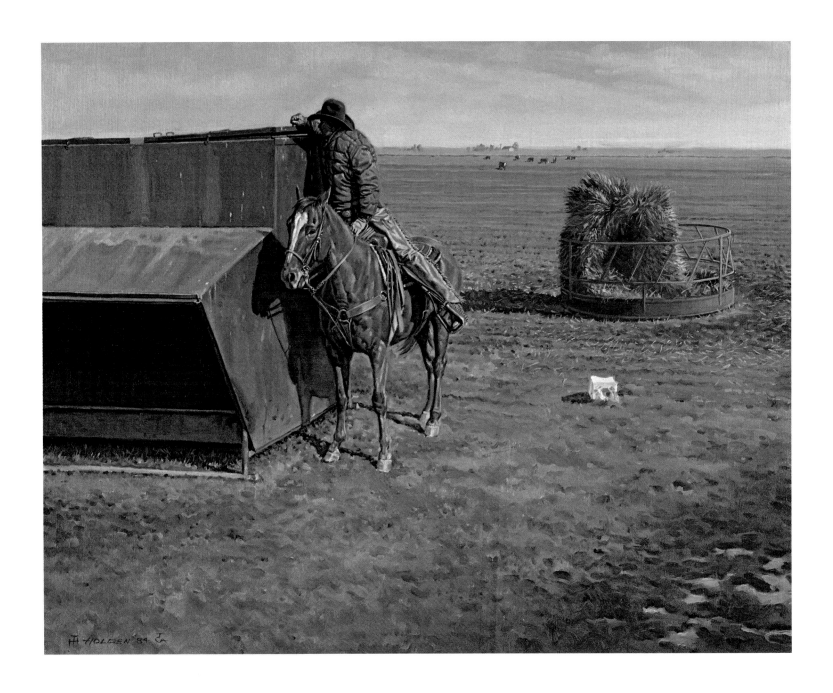

Harold Holden. *Checkin' the Feeder.*

Modern Cowboy Work—
Wheat Pastures, Stockyards, Feedlots, and Sale Barns

THE PRACTICE OF GRAZING stocker cattle on wheatfields during the winter months produced the wheat pasture cowboy, whose work season is from mid-November through April. Stocker cattle—young steers or heifers destined for feedlot fattening—put on weight on winter wheat. They are taken off the wheat in time to allow it to make a crop for harvesting.

Enormous wheatfields are divided into quarter-section pastures by means of electric fences that are easily put up and taken down. Each pasture holds from one hundred twenty to three hundred fifty head, and a cowboy may have as many as thirty pastures to check regularly.

Hauling a trained cow horse and perhaps a young animal he is training, the cowboy makes his rounds in pickup and trailer. His main concern is the condition of the cattle—he must check salt and mineral blocks and supplemental feed. He must spot sick or injured animals, and either rope and doctor them in the field or trailer them to a pen. He must also make a daily report.

During the off season a wheat pasture cowboy may work at stockyards, feedlots, or sale barns where cattle are auctioned. Stockyard work is mainly loading, unloading, and moving cattle from one pen to another. Most of it, at least, can be performed on horseback. Feedlot work involves less riding except when stocker cattle arrive or are shipped. Sale barn work is similar. In the off season cowboys often train horses for others or, if they are skilled ropers or riders, they may follow the rodeo circuit.

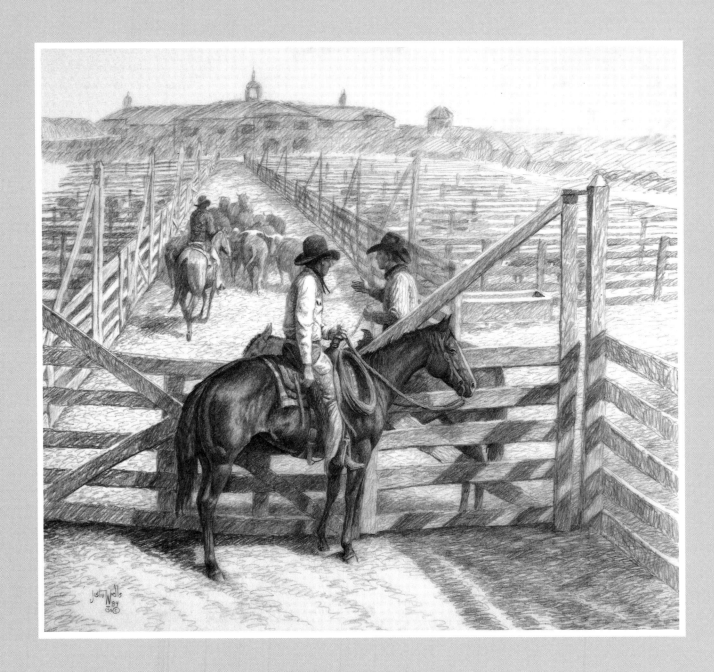

Justin Wells. *The Penriders.*

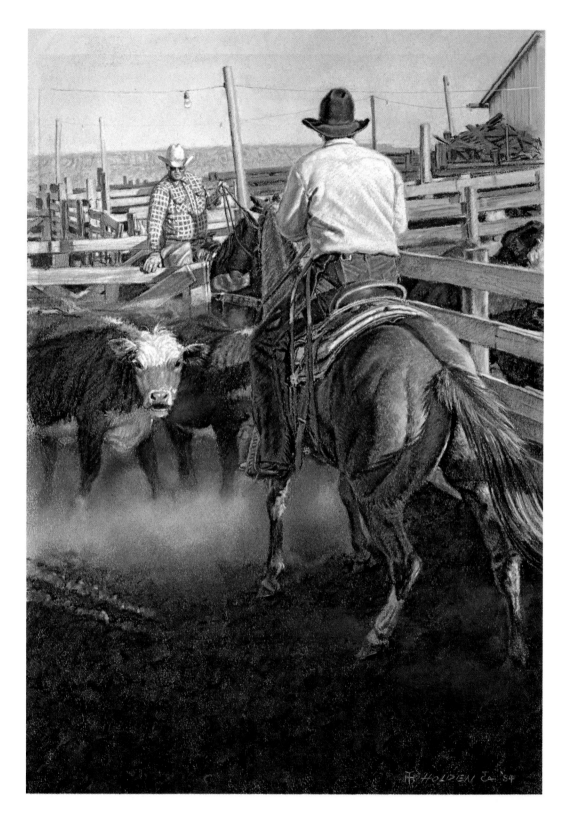

Harold Holden. *Pen 'Em!*

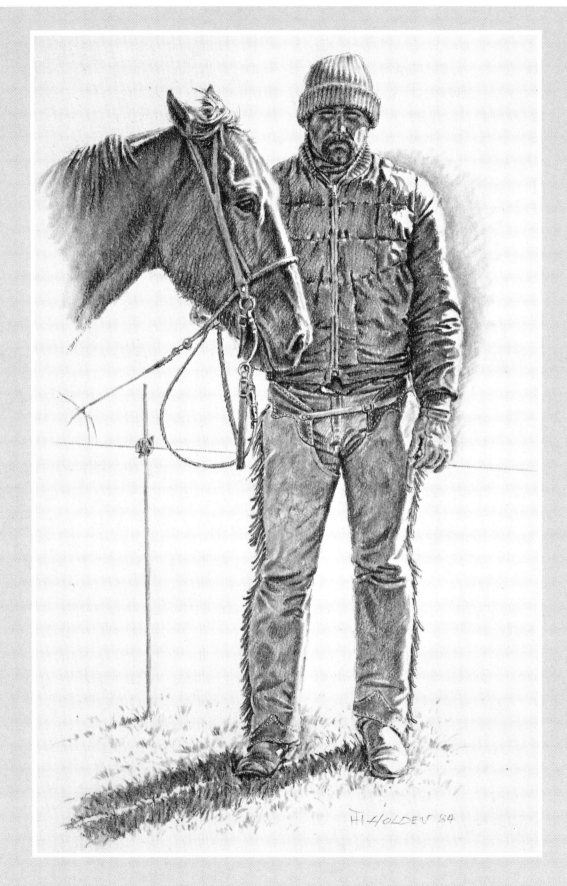

Harold Holden. *Jeff, by the Hot Wire.*

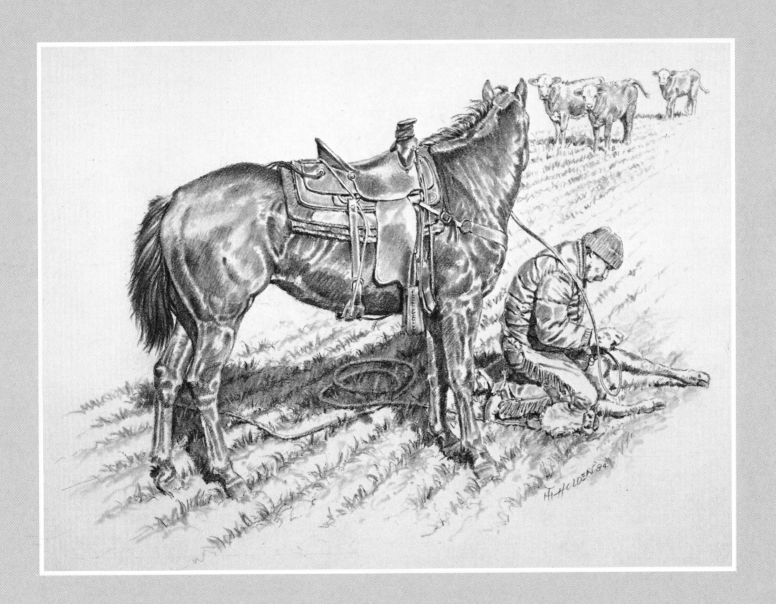

Harold Holden. *Cattle Corpsman.*

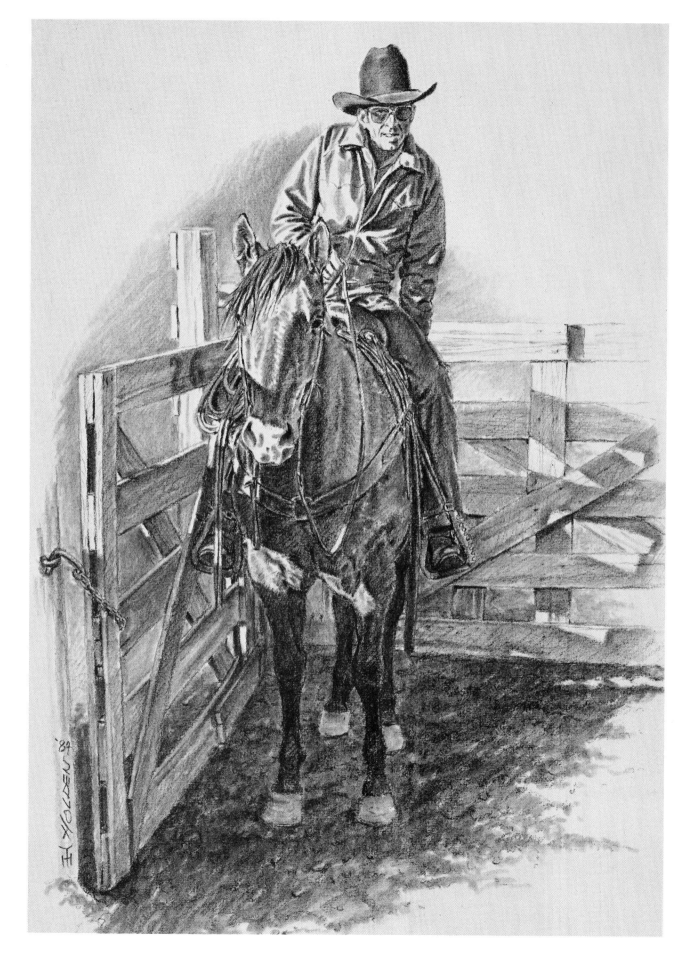

Harold Holden.
Alley Corner.

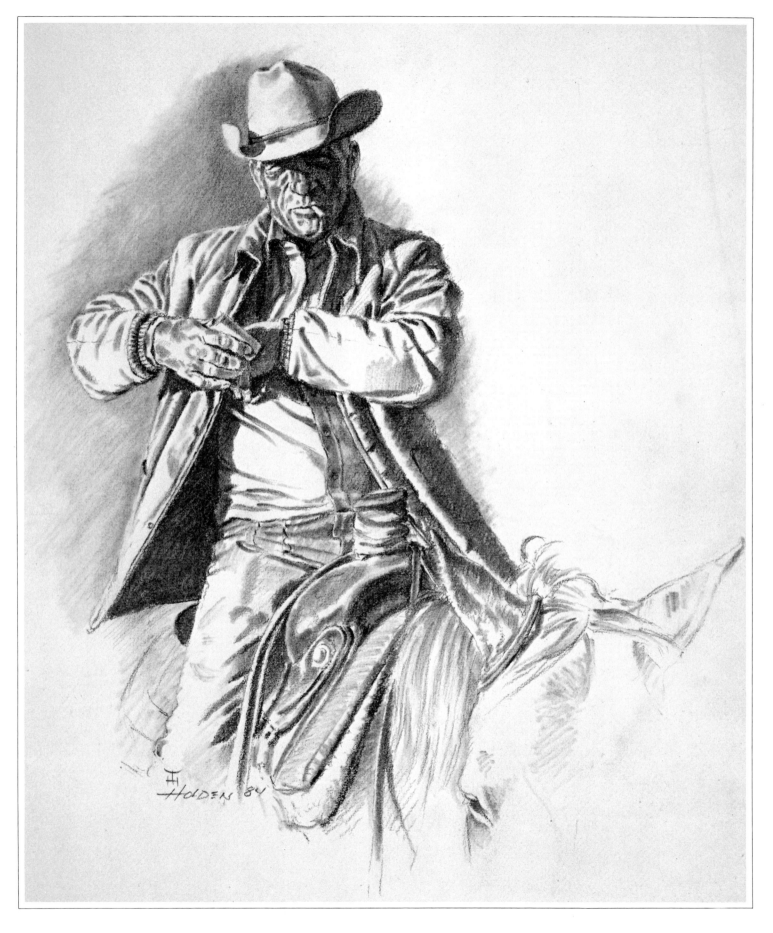

Harold Holden.
Lonnie.

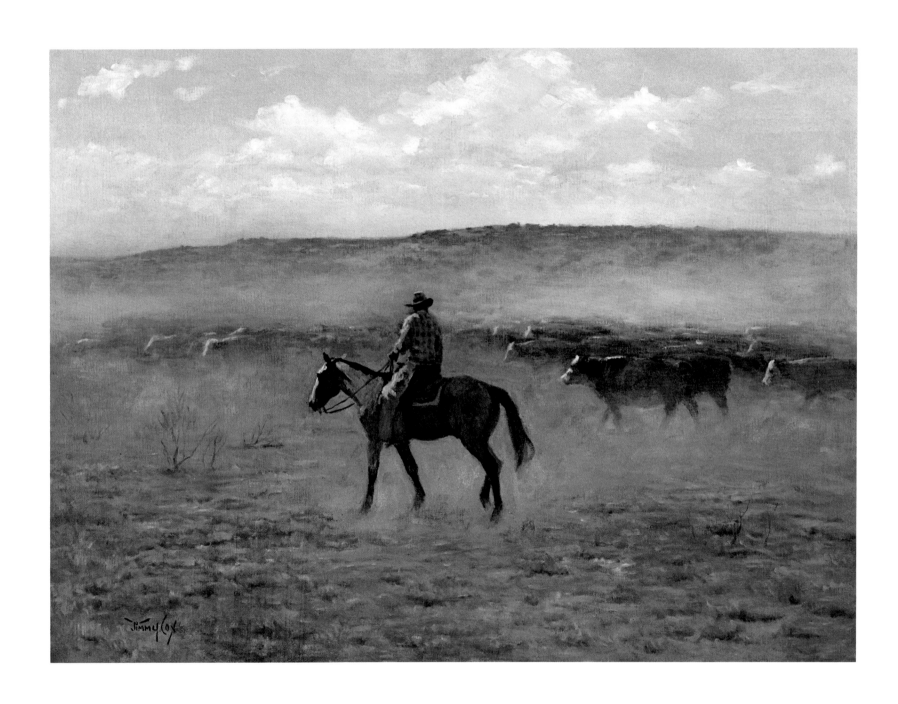

Jimmy Cox. *Eating Forty Pounds of Dust.*

Weaning, Doctoring, Spraying, and Dipping— The Roundup Today

LARGE RANCHES in rough country where it takes many acres to support a cow and calf still have hard-riding cowboys who must comb the brush and draws in enormous pastures. These roundups are somewhat similar to those of the open-range days, for the cattle may get a bit wild and there are many places for them to hide. Old-time roundups went on for several months, and the men were with the chuck wagon all that time. Today, big pasture roundups may last several days or longer, but the cowboys haul their horses to them in trucks or stock trailers. On some large ranches, helicopters are used to locate strays and to start cattle moving toward the corrals. In many instances, though, the chuckwagon still maintains its importance as the cowboy's temporary home.

On smaller ranches, especially those managed by one man and in brushy country, cow dogs have proven their worth over and again. Some local curs make good cow dogs, but there are two main kinds used in Texas: the Queensland Blue Heelers, a crossbreed from Australia, and the Catahoula Leopard, a smallish import from Louisiana. Both have natural cow-working instincts, just as other dogs are born bird hunters.

One brush country cowboy said, "My wife is more help in the brush than two town cowboys, and my Leopard dog is worth three of 'em!"

When Texans raised mainly Longhorns there was no need for concern about separating cows and calves, for Longhorn cows weaned their own offspring. Today, calves old enough to wean are separated from the cows at roundup and put in a pasture by themselves. Steers ready to be sent to feedlots are gathered and loaded in cattle trucks.

Longhorns were also immune to tick fever, although they were carriers of the disease. Today, roundup is the time to spray or dip to rid cattle of ticks. Regular dipping of all livestock first became mandatory in areas where the fever was endemic in the late days of the trailing era. After the State of Texas belatedly required regular dipping of all livestock in specified areas, some owners were outraged at seeing their pet horses or cows pushed into the dipping solution with cattle prods. At least once, irate women watched for an opportunity to apply the same treatment to dipping vat officials. Many modern ranches, lacking dipping facilities, corral and spray their cattle for ticks, lice, and scabies.

Bill Leftwich. *Cow Dog.*

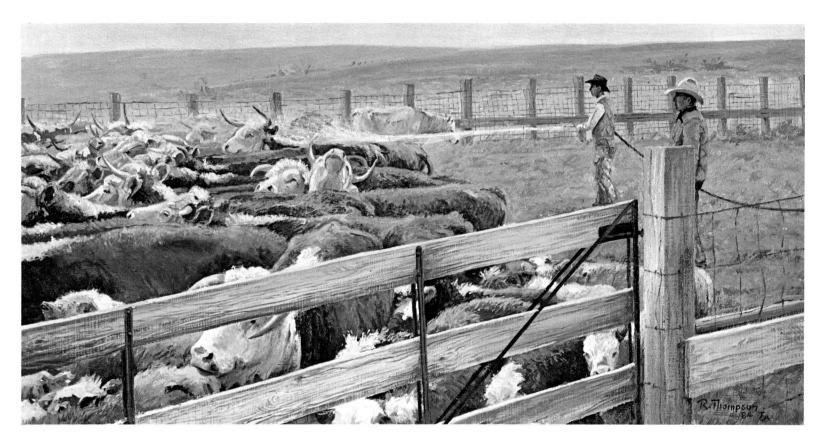

Richard Thompson. *Wet and Wild.*

Roundup is also the time to doctor cattle. Before screw-worm flies were controlled by releasing sterilized males, it was necessary to doctor any animal that had an open wound. The flies laid eggs in such wounds, and the growing larvae literally ate the animals alive. Today, cattle are immunized at roundup against blackleg and other bovine maladies. Other breeds of cattle lack the Longhorn's resistance to these diseases.

In spite of trucks and trailers, there is still much work to be done on roundup on the big ranches. But it is not the same as when the wild Longhorns were gathered, road branded in the open, and put on the trail to Kansas.

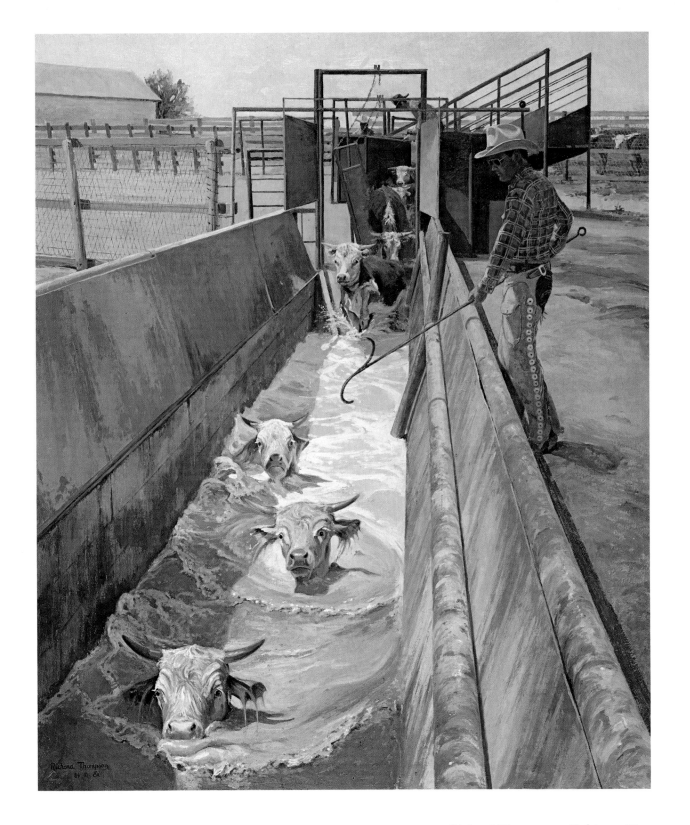

Richard Thompson. *Taking a Dip.*

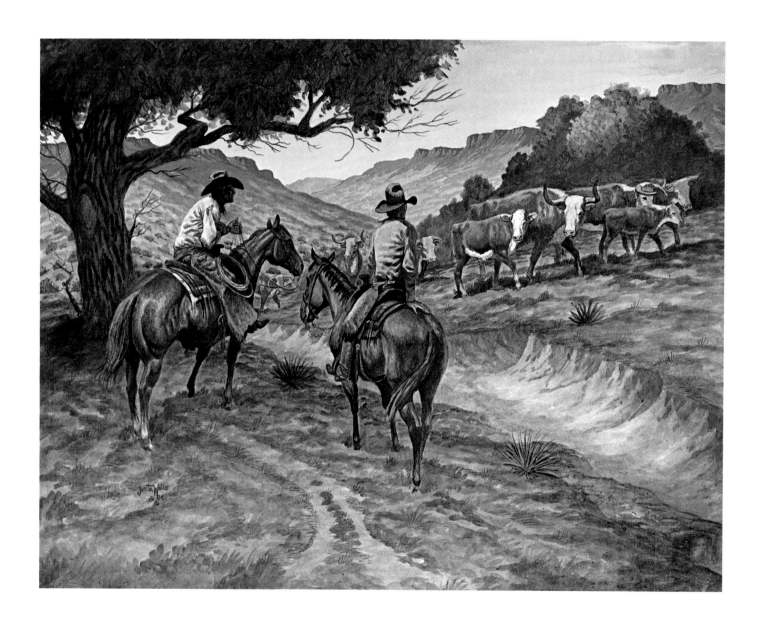

Justin Wells. *Checking his Crop.*

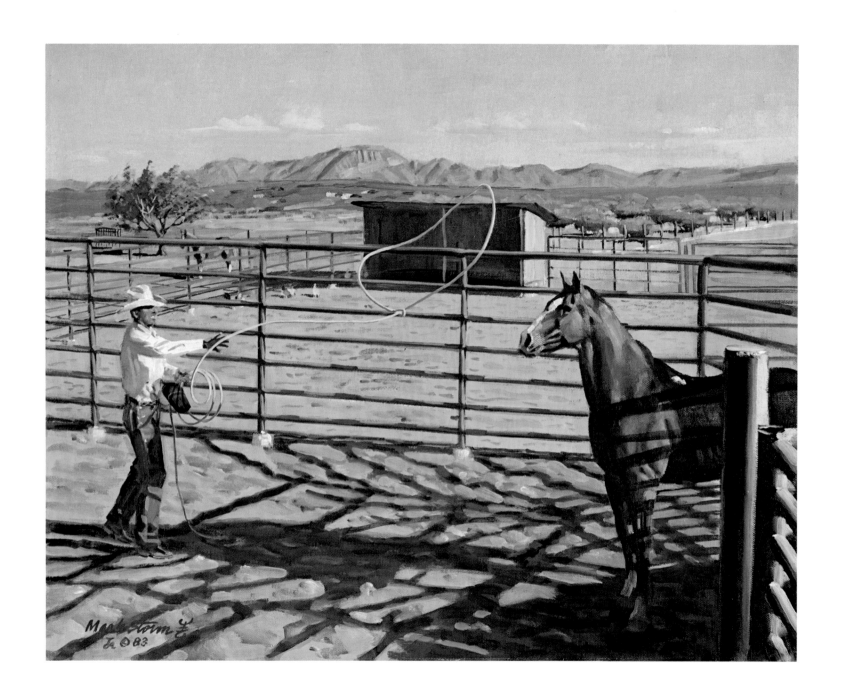

Mark Storm. *New Day—Old Loop.*

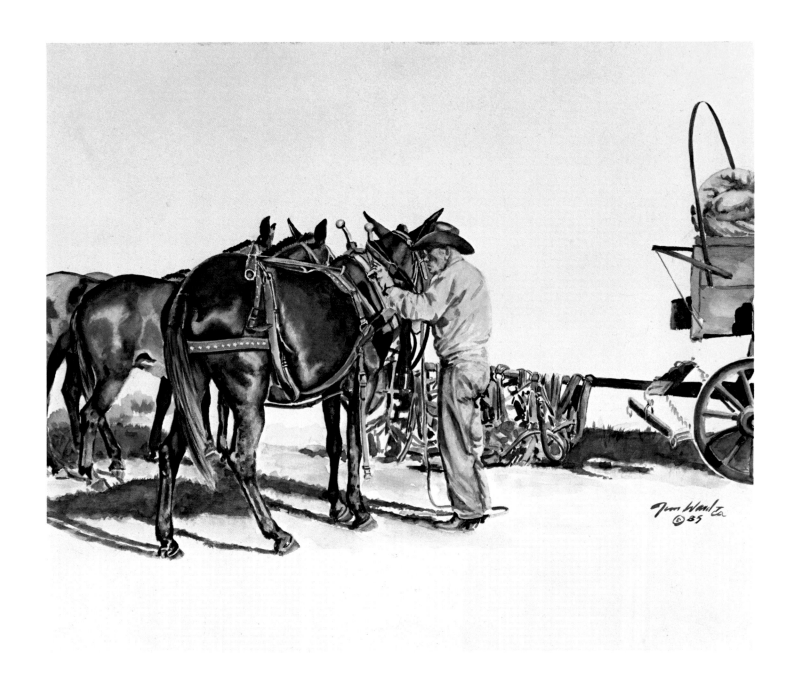

Jim Ward. *Harnessing Old Rhody.*

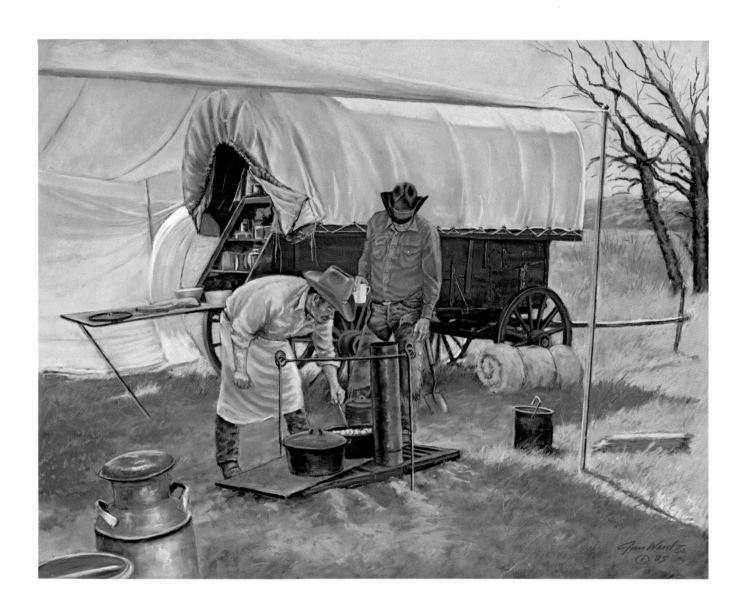

Jim Ward. *Sourdough and His Coffee.*

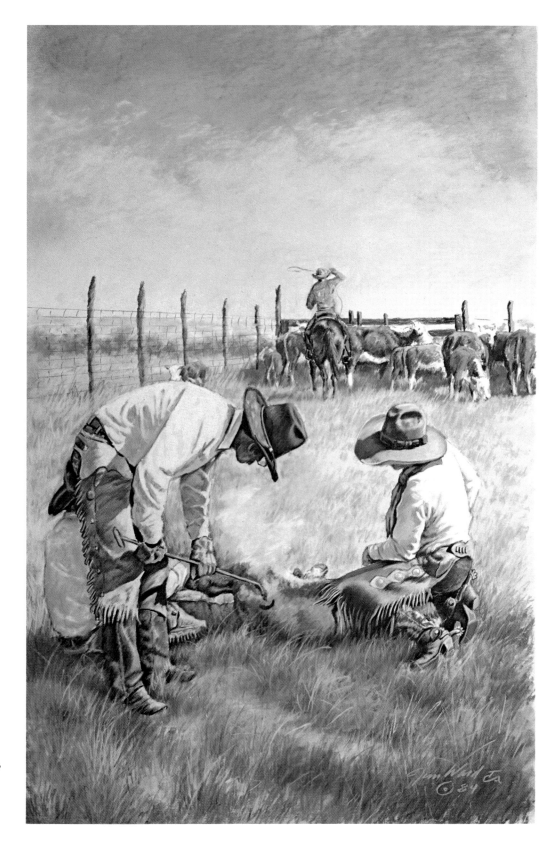

Jim Ward. *Quién Sabe?*

Black Gold Amidst the Green Grass

IN THE EARLY 1900s some of the largest ranches began to be broken up and sold. By 1906 the XIT had disposed of two million acres and in 1912 sold its last herd. The cattle market was notoriously unstable, and an untimely drop in beef prices could wipe out a year's profits. Beginning around 1910, oil and gas leases and royalties provided unexpected bounty for a number of fortunate Texas ranchers.

Only a few of the largest ranches gained much from oil and gas production. One of these was the W. T. Waggoner ranch east of Vernon, where the Electra oil field was tapped in 1910. Part of it lay under Waggoner land. W. T. Waggoner had hired a drilling company to drill water wells earlier, but to his disgust the water was polluted with oil and unfit for cattle. In 1920 a big strike was made in the center of his five-hundred-thousand-acre ranch.

In 1918 an oil boom began at Burkburnett on seventeen thousand acres Burk Burnett had sold to be subdivided among farmers. The rise in the price of oil leases increased the incomes of ranchers in the area, and oil was found later on Tom Burnett's ranch. Burk Burnett's Carson County ranch also received thousands of dollars from oil and gas royalties. The King ranch was another of the large ranches that benefited substantially from oil and gas production.

In 1927 one of the richest strikes on any ranch was made on Ira G. Yates' twenty-thousand-acre spread west of the Pecos. In 1937 another big strike was made on part of C. C. Slaughter's ranch in Hockley County, which his heirs still owned.

Although old-time cowmen might have disliked the sight of oil derricks on their ranges, they welcomed the income that enabled them to continue ranching through bad times as well as good. One byproduct of oil strikes on some ranches was that other ranch owners became cautious about selling their land out of fear that they might be giving away a fortune.

Jimmy Cox. *The Subsidy.*

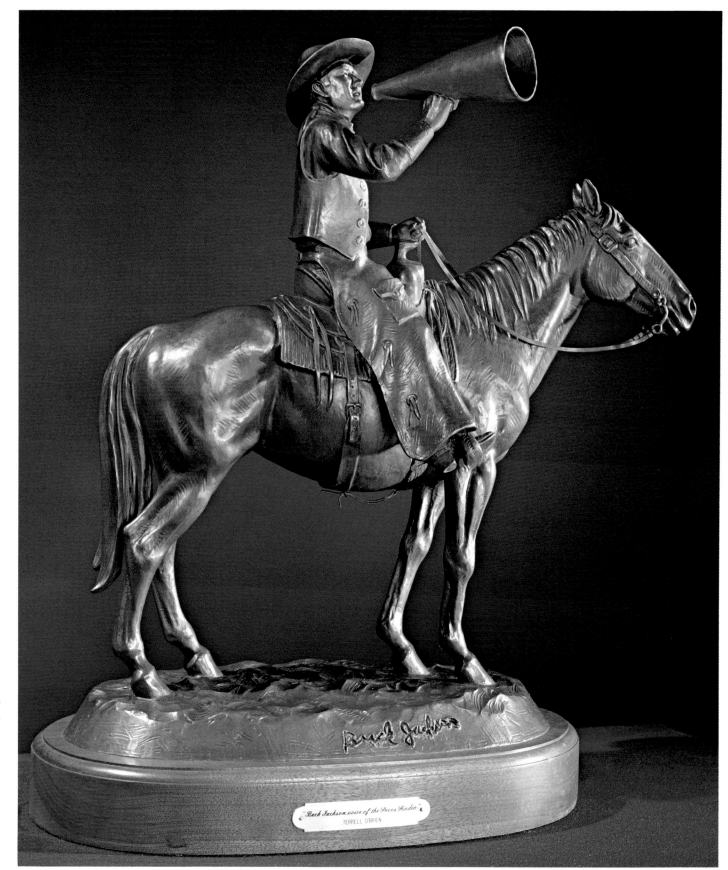

Terrell O'Brien.
Buck Jackson—
Voice of the Pecos Rodeo.

From Thirty and Found
to a World Championship

COWBOY ROPING AND RIDING contests occurred whenever cowboys from different ranches got together and had time for play. Most big ranches had an outlaw horse or two, and cowboys who were sure they could ride any critter with four legs were given the opportunity to try.

Wild West shows staged exhibitions of cowboy riding and roping skills, but the riders weren't competing for prize money. These shows did publicize the activities that became primary parts of rodeos.

The early rodeos were held in cow towns across the West, and the competitors were from neighboring ranches. Later a group of cowboys and cowgirls traveled in boxcars while their livestock went along in cattle cars from town to town. They put on rodeos wherever they could. Frequently they had to build the arenas, pens, and chutes, and most of the time they lived in tents while on tour.

This small group of professionals survived on their prize money, hoping to make it to the major show at Madison Square Garden in New York City. None became wealthy, but they loved the life. The women roped, rode bucking stock, and competed as trick riders. Almost without exception they were daughters of ranchers and had learned their skills by helping with ranch work.

No rodeo was complete without a colorful, leather-lunged announcer, who kept the crowd entertained and informed concerning riders and ropers. His public address system was a megaphone, and he rode back and forth in front of the stands. One of the most famous of the early announcers in Texas was Buck Jackson, who served the West of the Pecos Rodeo from 1928 to 1975. That rodeo was probably the first in Texas if not the West, and for most of his life cowman and sheriff Buck Jackson was "the voice of the Pecos Rodeo."

Rodeo riding became a professional sport with an organization, the Professional Rodeo Cowboys Association (PRCA), setting the rules. In 1946 the All Girls Rodeo Association was organized to sponsor rodeos for women contestants.

There are still small rodeos where local cowboys compete, but contestants in the large shows are PRCA members. Professional rodeo participants are mainly ranchers or cowboys, but some are city-bred men who have learned to ride bucking stock or to rope by attending schools that teach these skills. Some who come to rodeo from urban backgrounds are good enough to compete for championships.

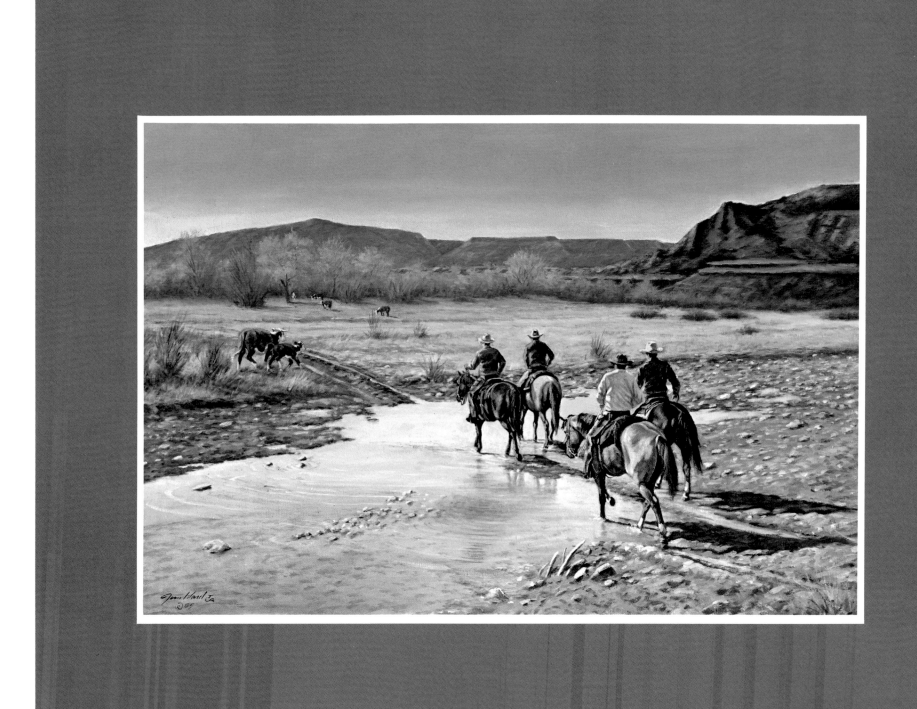

Jim Ward. *Working the Canyon.*

The Texas Cowboy Today

AFTER A CENTURY and a half, Texas still has cowboys and cattle ranges. On vast spreads like the Four Sixes and the King ranch, cowboys still make big pasture roundups, but they are of fat and relatively tame cattle, quite different from the old-time wild cow hunts of swift and unsociable Longhorns on unfenced prairies and in the thorn-infested brush country.

The cow stock that Texas cowboys work today are animals built for beef rather than speed, and they are accustomed to frequent handling. Gone are the multi-colored, lean and pugnacious critters of yesterday—in their place are plump white-faced Herefords, short-legged black Angus, red Santa Gertrudis, Charolais "white elephants," Simmentals, and other exotics recently introduced from Europe. Ranchers have learned that crossbred cattle are best for producing beef animals, and in the past half century the Longhorns, after barely being saved from oblivion, are again in demand for crossbreeding. They are valued for their lean beef, resistance to disease, ability to thrive on marginal pastures, and ease of calving.

Today's cowboys usually ride large and powerful Quarter Horses instead of small mustang cow ponies. Pickups, horse trailers, and cattle trucks have greatly reduced the time modern cowboys must spend in the saddle, but there is still much hard work to be done in winter as well as summer.

Texas cowboys, heirs to both southern and Spanish-Mexican cattle and horse handling techniques, spread their customs and practices over the Great Plains from the Rio Grande to the Upper Missouri in the era of the long drive and the open-range cattle kingdom. Theirs is a proud tradition and heritage; they made the cowboy a folk hero who today is popular all over the world.

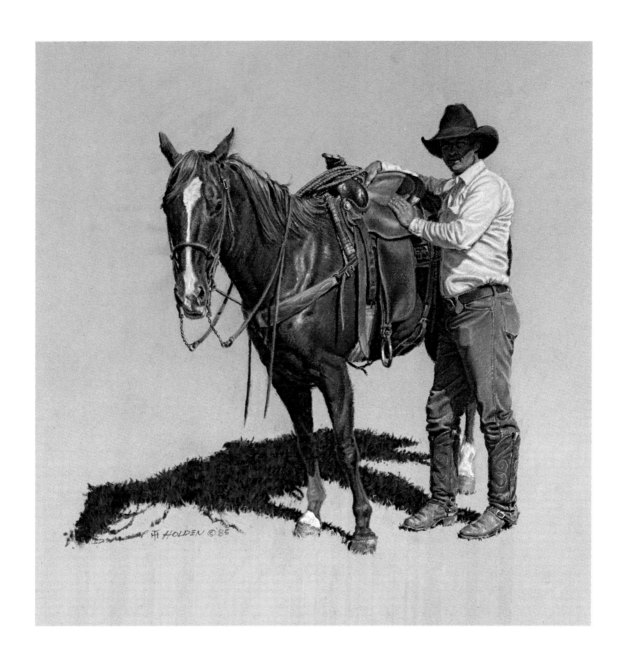

Harold Holden. *Rare Breed.*

Contributing Members of the Texas Cowboy Artists Association

Jimmy Cox
Cold-Jawed
Eating Forty Pounds of Dust
The Majestic Breed
The Subsidy

Steve Devenyns
Bringing in New Blood
Cowboy's Kitchen
Eatin' Dust
End of an Era
New Face of Texas
Snowbound
Spring in Cheyenne
Starting the Gather
Trailin' Old Blue
Untitled
Wild and Free

Lee Herring
Matilda Lockhart Comes Home

Harold Holden
Alley Corner
Buffalo Springs on the Chisholm Trail
By a Nose
Cattle Corpsman
Checkin' the Feeder
Drag
First Day in School
The Harmonizer
Jeff, by the Hot Wire
Lonnie
Nighthawk

The Texas Cowboy
is set by G & S Typesetters in Melior type
designed by the German type designer
and calligrapher Hermann Zapf.
The photography is by
Linda Lorenz.
Printing by Hart Graphics and
binding by Universal.
Design by Whitehead & Whitehead.
1 9 8 6